PRAISE FOR *THE SKETCHNOTE...*

"The practical lessons in *The Sketchnote Workbook* make it easy and fun
for anyone to leverage visual note taking to help them remember more,
communicate better, and develop ideas more completely."
— Todd Henry, author of *Die Empty*

"If you want to succeed in capturing and communicating your ideas,
you need to read this book. Because it's not merely a book:
It's a blueprint for a new way of thinking, and it's fantastically useful."
— Daniel Coyle, *The New York Times* best-selling author of
The Talent Code and *The Little Book of Talent*

"Mike has created a resource that will inspire anyone to take their doodling to a new level
and begin using sketchnoting in every aspect of their lives. After reading this book,
I know my recipe cards and travel journals will never look the same again!"
— C.C. Chapman, author of *Amazing Things Will Happen*

"Mike Rohde wants you to understand a simple idea: Drawing aids thinking.
Or, even better, drawing IS thinking. I fully agree with him: Pen and paper amplify our
thinking when we use them to record what we see, and to reflect on what it means.
This book, as its predecessor, *The Sketchnote Handbook*, will not just make
you a better artist, it'll make you a better thinker."
— Alberto Cairo, author of *The Functional Art*

"I present information as narrated visuals so Mike's approach makes a lot of sense to me.
Visuals are key to understanding complexity, and the combination of images and text
as notes is always more effective than notes alone.
Sometimes they are more effective than the original presentation."
— Horace Dediu, founder of Asymco

"We humans are visual! So if you want to build your creativity and communication skills
in order to facilitate the most powerful business meetings and give genius presentations,
then *The Sketchnote Workbook* is one of the most fun and effective ways I know to do it. "
— Mark Bowden, president of TRUTHPLANE® Communication Training
and author of *Winning Body Language*

"Learning to capture the world in pictures and words changed my life, but it took me years
of trial and error. How I wish I'd had Mike Rohde's generous books as guides!"
— Austin Kleon, author of *The New York Times* best-seller *Steal Like an Artist*

the Sketchnote WORKBOOK

→ ADVANCED *techniques* FOR TAKING ←
VISUAL NOTES YOU CAN USE *anywhere*

by MIKE ROHDE

author of The Sketchnote Handbook

THE SKETCHNOTE WORKBOOK
Advanced techniques for taking visual notes you can use anywhere

Mike Rohde

Peachpit Press

Find us on the Web at **www.peachpit.com**
To report errors, please send a note to errata@peachpit.com

Peachpit Press is a division of Pearson Education.

Acquisitions Editor: Nikki Echler McDonald
Development Editor: Jan Seymour
Production Editor: Tracey Croom
Proofreader: Liz Welch
Indexer: James Minkin
Cover Design and Illustrations: Mike Rohde
Interior Design and Illustrations: Mike Rohde
Video Producer: Brian Artka
Media Producer: Eric Geoffroy

BEST CREW IN *the* WHOLE 'VERSE!

ISBN 13: 978-0-133-83171-9
ISBN 10: 0-133-83171-X

9 8 7 6 5 4 3 2 1

Printed and bound in the United States of America

This book is dedicated to Gail, Nathan, Linnea, Landon,
Mom, Dad, and all of my dear friends and community.
I couldn't have created this book without your support.

We did it!

ACKNOWLEDGMENTS

THE SKETCHNOTE WORKBOOK WAS GOING GREAT, until it turned upside-down with a family medical emergency halfway through its creation. Without a doubt, the supportive network and amazing editors and publisher kept this book you're reading alive. My deepest thanks go to family, friends, colleagues, and the sketchnote community for supporting us when everything seemed against us.

GAIL, you're the reason I do the work I do. We've been through some painful, difficult days in this season of our lives, but we're hanging in there. Thanks for your consistent, amazing support of what I love to do. I love you!

NATHAN, LINNEA, AND LANDON, thanks for your support as I worked on a second book project. My wish for you is that the work I'm doing makes you very proud and that you love telling people your daddy wrote some pretty cool books.

NIKKI McDONALD, thanks for being my biggest fan and sticking with me, believing in me, and working so hard to make this second book come to life. In spite of all the challenges we've faced together, you've been steady. I'm so proud of having worked with you to create two amazing books that are like nothing else.

JAN SEYMOUR, I've had a blast having you as my editor. You've embraced my book from the start and together we've made this book even better than *The Sketchnote Handbook*. Thanks for cheering me on when things seemed darkest.

PEACHPIT, your team was my secret weapon, once again. Thank you, Liz Welch for your eagle eye, James Minkin for another perfect index, Tracey Croom for making this a superb-looking book, and Eric Geoffroy for providing expert knowledge to create another fantastic video.

DAVID FUGATE, I appreciate your guidance as my agent through another book project. Thanks for answering every crazy question I come up with.

BRIAN ARTKA, thanks for telling my story with video and for being a great friend. You are always willing to push me to do my best and achieve excellence. I wouldn't want to tell a story through video with anyone else.

DELVE WITHRINGTON, years ago we created The Sketchnote Typeface and now I have a second book set in it . Thanks for making book production so much easier for me and for making foreign translations much more likely.

GABE WOLLENBURG, thanks for your sense of humor and your immediate willingness to create another fabulous screenplay for my video. You rock!

STEPHEN MORK, thanks for creating a fun, encouraging, and danceable soundtrack. Your music adds a perfect positive vibe to the video.

ERIC RESCH, JOE SORGE, MARK FAIRBANKS, CYNTHIA THOMAS, JON MUELLER, TOM & KATE GOMOLL, AND CYNTHIA LeVAN, thanks for letting us use your spaces in the *Workbook* video to show viewers that Milwaukee is a cool place to be.

FEATURED SKETCHNOTERS: Don Pollitt, Jackie Pomeroy-Tso, Julie Stitt, Mauro Toselli, Chris Spalton, Sam "Pub" Smith, and Doug Neill, thanks for sharing your sketchnoting journeys and experiences—not to mention your work.

FRIENDS AND COLLEAGUES, thanks for your reviews and feedback about the book and video as I created it. This is a better book because of your help.

TO THE SKETCHNOTING COMMUNITY, this book is for you. Thanks for your strong support and encouragement along with sketchnote contributions as I labored to create this book. I can't wait to see how you'll use and improve these new ideas!

ABOUT THE AUTHOR

MIKE ROHDE has a passion for simple and usable design solutions. That passion, along with his lifelong habit of recording concepts and observations through sketching and doodling, inspired him to develop sketchnotes—a practical art that translates simple and complex ideas into easily recalled bits of information.

Professionally, Mike focuses on user interface, user experience, visual design, and icon design for mobile and web applications at *Gomoll Research + Design* in Milwaukee, Wisconsin.

Mike's popular first book, *The Sketchnote Handbook*, convinces people around the world to become sketchnoters every day. Translated into German, Russian, Chinese, and Czech, it guides readers in using their natural visual capabilities to create sketchnotes for better understanding, and to have fun taking notes.

He enjoys speaking publicly about his passion for sketchnoting, sketching, and visual thinking skills at venues across the United States.

In his illustration practice, Mike uses his unique drawing style to amplify and clarify ideas. His work is featured in *REWORK* and *REMOTE*, two best-selling books by Jason Fried and David Heinemeier Hansson; *The $100 Startup*, a best-selling book by Chris Guillebeau; and *The Little Book of Talent* by Daniel Coyle.

Community and sharing are important cornerstones of Mike's philosophy, as evidenced by the creation of *The Sketchnote Army*, a website dedicated to finding and showcasing sketchnotes and sketchnoters from around the world.

Mike has also shared his thinking, design process, and samples of his design and illustration work at his personal website, **rohdesign.com**, since 2003.

Mike lives with his wife, Gail, and children, Nathan, Linnea, and Landon, just outside of Milwaukee. He's an avid Green Bay Packers fan.

Learn more about Mike at **rohdesign.com**.

Chapter 1

👁 SKETCHNOTING QUICKSTART OVERVIEW 2

What sketchnotes are, the elements that make them up, and the techniques and approaches used to capture and map ideas with words and images.

Chapter 2

⚡ SKETCHNOTE IDEA GENERATION 14

Sketchnoting is a great tool for capturing ideas, on your own or while working with a team. During the idea generation process, sketchnoting helps you amplify ideas and gives you the freedom to explore.

Chapter 3

🗺 SKETCHNOTE IDEA MAPPING 38

Sketchnotes don't have to be the end result of visual thinking. You can use sketchnoting as a valuable step in the middle of a project to analyze and better understand information.

Chapter 4

▦ SKETCHNOTE PLANNING 66

Sketchnotes are well suited for planning. Use them to plan ahead visually for projects like simple task lists, family vacations, work assignments, and more.

Chapter 5

SKETCHNOTE DOCUMENTATION 92

Sketchnoting is an effective way to convert information into concise visual documents that communicate processes and ideas.

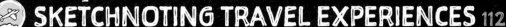

INTRODUCTION

A YEAR AND A HALF AGO, *THE SKETCHNOTE HANDBOOK* WAS RELEASED INTO THE WORLD. Frankly, I was nervous about the launch. I had no idea how my first book would be received.

Boy, was I wrong to worry! *The Sketchnote Handbook* launched to immediate excitement from its readers. I received a constant stream of positive social media mentions, encouraging email messages, and more positive book reviews than I would have imagined. It was an awesome experience.

Invitations to appear on podcasts came in while reviews were posted on blogs and websites. Within a few months, Peachpit Press had to print more copies of the *Handbook* video edition due to brisk sales.

German and Russian publishers licensed and printed *Handbook* translations, which became hits in those countries, while Czech and Chinese publishers licensed the book for their own native versions of the *Handbook*.

I spoke on sketchnoting in Portland, Austin, San Antonio, and Chicago, selling out of the books I'd brought with me. I was stoked when Moleskine reached out to create a limited-edition custom sketchbook to give away at SXSW in Austin.

All I could think was, *"Wow, this book is a hit!"* And I still receive positive feedback from people all over the world.

Why such positivity? Business owners, consultants, designers, developers, writers, doctors, teachers, students, and parents all tell me how my *Sketchnote Handbook* has changed their mindset. For many, the book has encouraged them to more deeply engage in and understand the ideas they're seeing and hearing.

People tell me that sketchnoting has given them the freedom and flexibility to play with ideas, enabling them to create meaningful visual documents that help them better understand and remember ideas and experiences.

The constant flow of positive feedback, blended with my desire to share more ways to apply sketchnotes, inspired me to write *The Sketchnote Workbook*.

WHAT IS *THE SKETCHNOTE WORKBOOK?*

Capturing meeting notes or sessions at conferences is a great way for readers to immediately apply sketchnoting techniques and see great value in the approach. The hundreds of sketchnotes I've seen since the release of the *Handbook* verify it. But there are still many more ways sketchnotes can be used that I want to share.

As a veteran designer, I use sketchnotes for idea generation and idea mapping daily. For years I've created travel and food sketchnotes that transport me back to memorable experiences.

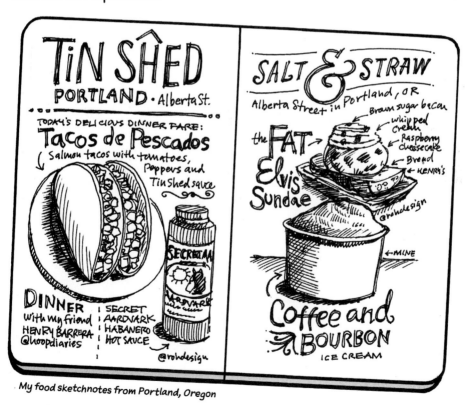

My food sketchnotes from Portland, Oregon

But it's not just me. Friends in the sketchnoting community constantly share how they use sketchnotes to document processes, plan projects, and capture ideas in books, movies, TV shows, and sporting events.

I've collected the techniques I've learned from fellow sketchnoters in the community, waiting for the right time and place to share them. You'll find this workbook full of new sketchnoting ideas, plenty of worksheets, and a range of challenges designed to rapidly improve your sketchnoting skills.

My hope is that by working through this book, you'll be inspired to try new sketchnoting ideas. I'd love to see you adopt advanced drawing techniques to tackle the tougher sketchnoting challenges you've been avoiding—until now.

The Sketchnote Workbook - Chapter 6

HOW TO USE THIS BOOK

I've created this book and video to be enjoyed in one go, or used as a reference you can jump around in. If an idea grabs you, try it out! Experiment until it fits your way of working.

The ideas in this book are here for you to iterate on and improve. Worksheets and challenges in the book aren't rigid or designed to have just one correct answer. Rather, this book and its exercises should be seen as experiments and not assignments. Have fun playing and exploring!

JOIN THE COMMUNITY

As you explore ideas in this book, share your work with the sketchnoting community. We're welcoming and encouraging to everyone. Start at *The Sketchnote Handbook* Flickr group, **flickr.com/groups/thesketchnotehandbook** and then stop by *The Sketchnote Army*, **SketchnoteArmy.com**.

You'll see the work of many others that will inspire and challenge you. I look forward to you joining the discussion!

REACH OUT

Please reach out and say hello. Check out my sketchnotes, read my writing, and sign up for my free newsletter at **rohdesign.com**. I'm a very active Twitter user, so reach out at **twitter.com/rohdesign**.

I look forward to hearing how you apply ideas in the *Workbook* and seeing what new ideas you come up with for using sketchnotes in your own life.

ALL RIGHT, ENOUGH TALK—IT'S TIME FOR ACTION.
GRAB A NOTEBOOK AND A PEN.
LET'S SKETCHNOTE!

ROCK & ROLL!

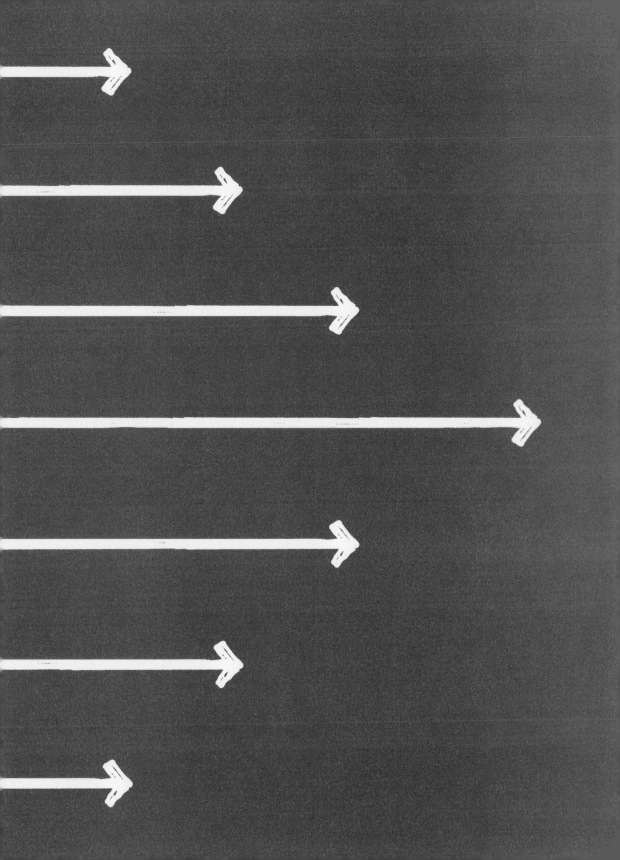

Chapter 1

SKETCHNOTING QUICKSTART *Overview*

Let's talk about what sketchnotes are,
the elements that make them up,
and the techniques and approaches used to
capture and map ideas with words and images.

IN MY FIRST BOOK,

The Sketchnote Handbook, I shared the idea of sketchnotes by providing a beginner's guide to the process: *what* they are, *how* they are created, and *why* to create them.

I COVERED listening techniques, drawing and lettering techniques, and featured lots of sketchnote samples.

Most of the emphasis was on sketchnoting while listening to lectures and attending meetings.

IN THIS CHAPTER, WE'LL REVIEW THE BASICS OF SKETCHNOTING. THIS WAY WE CAN BEGIN ON AN EVEN PLAYING FIELD.

If you've read *The Sketchnote Handbook*, you may jump ahead to Chapter 2. Need *The Sketchnote Handbook*? Visit my site for details:

sketchnotehandbook.com

What ARE Sketchnotes?

SKETCHNOTES are rich visual notes created from a mix of handwriting, drawings, hand-drawn typography, shapes, and visual elements like arrows, boxes, and lines.

hand-drawn type drawings arrows

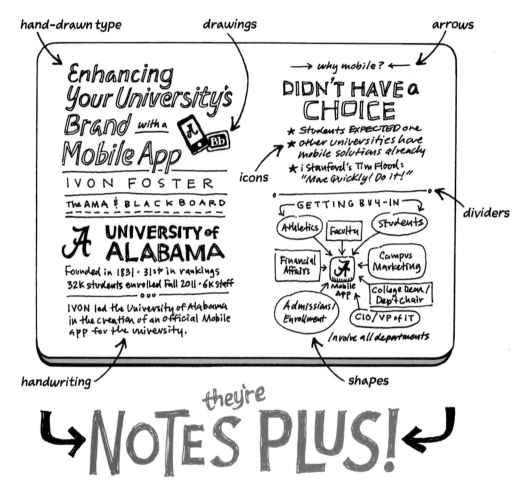

handwriting shapes icons dividers

↳ NOTES *they're* PLUS! ↵

I call sketchnotes Notes Plus because they're like the notes you already take, with visual elements added to amplify ideas.

— ✝ —

SKETCHNOTES EMPHASIZE CAPTURING BIG IDEAS IN THE

Moment.

WHY SKETCHNOTE?
Because it engages your whole mind.

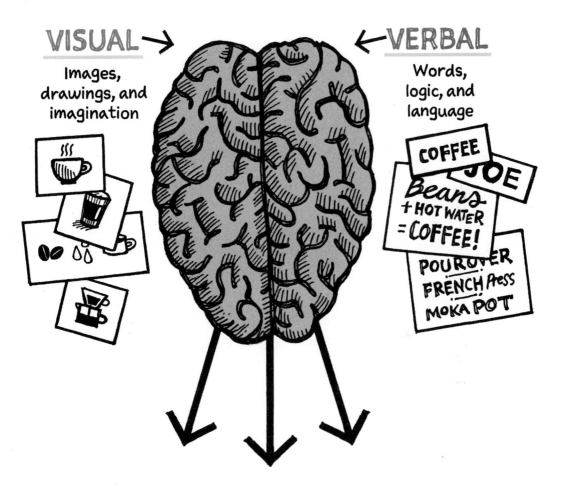

VISUAL →
Images, drawings, and imagination

← VERBAL
Words, logic, and language

COFFEE
JOE
Beans + HOT WATER = COFFEE!
POUR OVER
FRENCH Press
MOKA POT

When your **WHOLE BRAIN** is engaged, you create **VISUAL MAPS** of what **YOU HEAR, SEE, AND THINK.**

SKETCHNOTES
FOCUS
ON BIG IDEAS,
Emphasizing

LISTENING AND ANALYZING, ALONG WITH CHOOSING IDEAS THAT

RESONATE.

Immerse yourself in what you're hearing and thinking.
Cache ideas, make connections, and spot patterns.
Illustrate these patterns visually.

AT FIRST, SEEKING IDEAS THAT RESONATE WILL FEEL AWKWARD. THAT'S NORMAL.

But as you practice, you'll get better at it.
Important ideas will reveal themselves.

the 5 Elements of Drawing

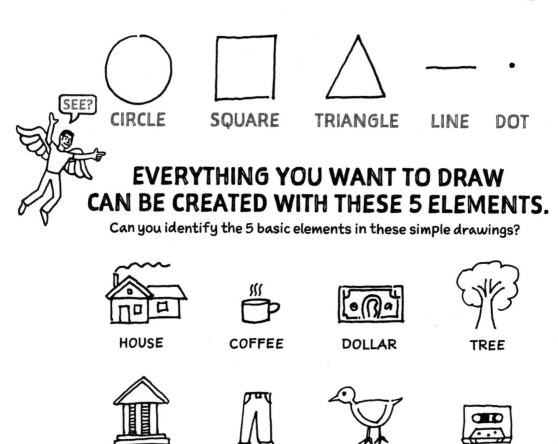

SEE?

CIRCLE SQUARE TRIANGLE LINE DOT

EVERYTHING YOU WANT TO DRAW CAN BE CREATED WITH THESE 5 ELEMENTS.

Can you identify the 5 basic elements in these simple drawings?

HOUSE COFFEE DOLLAR TREE

BANK JEANS BIRD MIXTAPE

ONCE YOU SEE THESE 5 ELEMENTS making up the objects around you, it becomes much easier to draw all sorts of objects...like...

RATS.

DRAWING PEOPLE

Drawing people is a helpful skill you can use in your sketchnotes.
Here are two ways to draw people — the *Star Method*
and the *Dave Gray Method*:

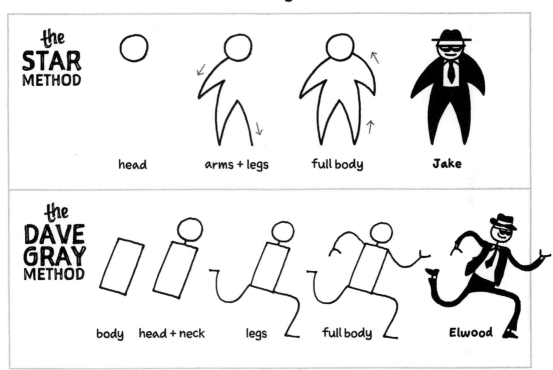

the **STAR METHOD**

head arms + legs full body **Jake**

the **DAVE GRAY METHOD**

body head + neck legs full body **Elwood**

DRAWING FACES

With just a few basic lines you can create a wide array of facial
expressions. My friend Austin Kleon has a simple way of creating
9 different faces by using just 3 different lines within a matrix:

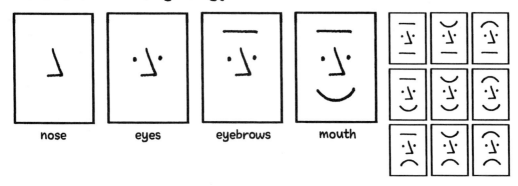

nose eyes eyebrows mouth

DRAWING TYPE

Hand-drawn type is a great way to make your sketchnotes more interesting and to define hierarchy. There are four easy methods you can use in your sketchnotes:

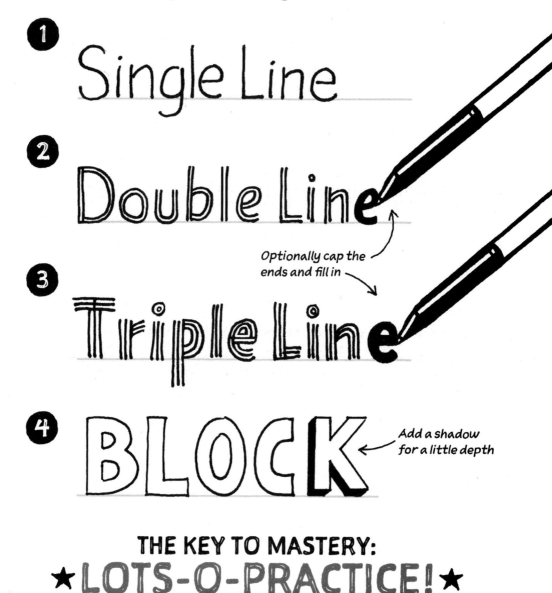

1 Single Line

2 Double Line

Optionally cap the ends and fill in

3 Triple Line

4 BLOCK

Add a shadow for a little depth

THE KEY TO MASTERY:
★ LOTS-O-PRACTICE! ★

TYPES of SKETCHNOTES

The foundation of a good sketchnote isn't about art—
it's about good structure. Here are the seven most common
sketchnoting patterns I've found:

LINEAR
Like a book,
left to right,
top to bottom.

RADIAL
A central hub
with many spokes
of information.

VERTICAL
Information
runs from top
to bottom.

PATH
Information
winding across
the page.

MODULAR
Information
broken up into
sections.

SKYSCRAPER
Information
aligned in
columns.

LOGICAL FLOW

POPCORN
Information
placed randomly.

BUILD A HIERARCHY OF INFORMATION

ELEMENTS of SKETCHNOTES

You can use a variety of elements as you build your sketchnotes. Not only do the elements support your ideas but many of these can add another level of interest:

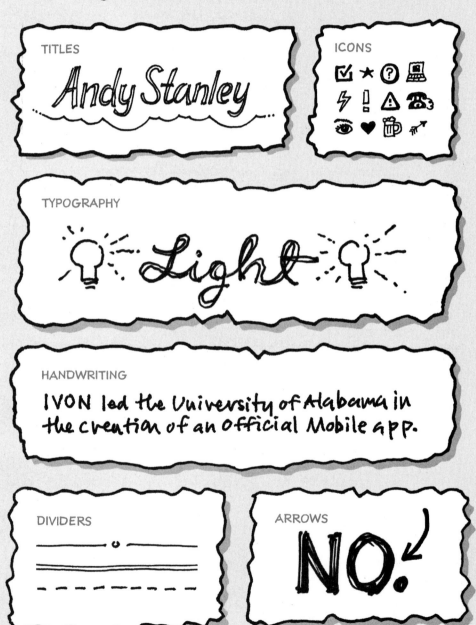

TITLES

Andy Stanley

ICONS

TYPOGRAPHY

Light

HANDWRITING

IVON led the University of Alabama in the creation of an Official Mobile app.

DIVIDERS

ARROWS

NO!

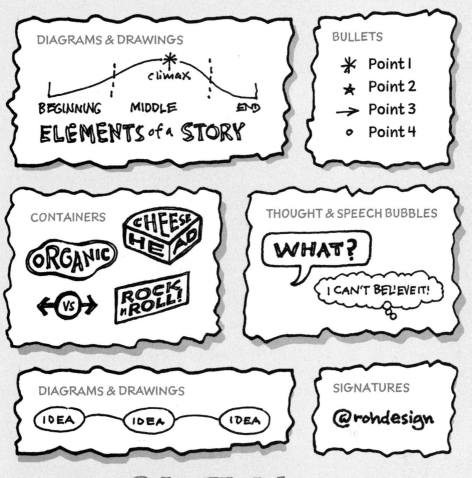

LET'S SKETCHNOTE!

Now with the basics under your belt, *The Sketchnote Workbook* will help you apply these ideas so you can create more varied and elaborate sketchnotes.

IN UPCOMING CHAPTERS we'll cover ways to apply these elements to idea generation, mapping, planning, documentation, travel, food, media, and advanced techniques.

READ ON AND LET'S HAVE SOME FUN!

GENERATE MAP PLAN DOCUMENT

Chapter 2

SKETCHNOTE
IDEA GENERATION

Sketchnoting is a great tool for capturing ideas,
on your own or while working with a team.
During the idea generation process,
sketchnoting helps you amplify ideas and gives
you the freedom to explore.

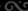

IDEA GENERATION

THE IDEA GENERATION PROCESS starts with observing your thinking around a topic: identifying your ideas and using sketchnotes to capture those ideas on paper. You can then review, refine, and communicate your ideas.

OBSERVE your THOUGHTS

IDENTIFY & CAPTURE IDEAS

REVIEW, REFINE, & COMMUNICATE

SPEED *and* FLOW ARE IMPORTANT!
Stay Loose ★ Work Quickly ★ Get Crazy!

`TIP` **TIMEBOXING**

Timeboxing is a great way to keep your idea generation sessions loose and focused on big ideas instead of hung up on little details. The method involves committing to a fixed period of time for the session, evaluating your progress after the session, and then repeating.

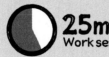 **25min** Work session

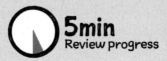 **5min** Review progress

 Repeat

Choose a time span, keep your mind moving, and create ideas quickly.

THE POWER OF VERBAL + VISUAL THINKING

Sketchnoting is powerful because verbal and visual areas
of your brain are working together to create a richly detailed
visual map of your ideas and thoughts.

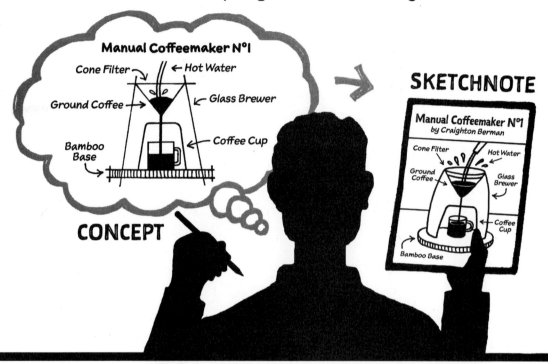

CONCEPT

SKETCHNOTE

ONCE AN IDEA IS *REAL*—LIKE A SKETCHNOTE ON PAPER—YOU HAVE SOMETHING *CONCRETE* TO WORK WITH.

Ideas made physical can help you spot great concepts,
find flaws in your thinking, and spark new ideas and directions.

THE FREEDOM TO EXPLORE IDEAS

Sketchnoting ideas offers lots of flexibility. Because
this is a process of generating raw ideas and not
finished concepts, your mind is under less pressure
to be perfect and is free to explore more options.
Your mind is given permission to play with ideas.

IDEA GENERATION FORMATS

Formatting your page ahead of time breaks idea generation into more manageable chunks. Formats can help alleviate *blank page paralysis* because you're focused on generating one idea at a time.

Numbering your ideas helps you identify specific concepts and reconstruct your thought process. Numbering is especially useful if you need to communicate your ideas with others.

THREE FORMATS

Here are three formats I've found useful at this stage of the process:

GRID
Divide your page into a grid, numbering each grid square. A few large grid spaces (4 per page) allow for more detail, while several smaller grid spaces (10 to 12) focus on many, quickly generated ideas.

RADIAL
Place the main idea, topic, or reference notes in a central hub. Using the free space around the central hub, add your notes, drawings, and icons, and separate subideas with dividers if you like.

FREEFORM
With this wide open format, you have the freedom to start anywhere on the page and let ideas dictate what is captured and where. Typically your ideas will follow a path of creation, so number each step in your process as you go.

GRID FORMAT

This format works well if you have a set amount of ideas you'd like to generate. I like writing out specifications or requirements just above the grid.

The TOPIC TITLE

Description and references related to the topic can go here

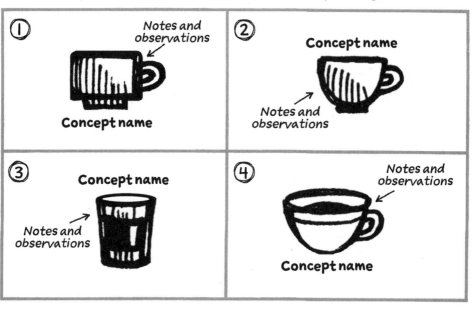

① Notes and observations

Concept name

② Concept name

Notes and observations

③ Concept name

Notes and observations

④ Notes and observations

Concept name

Four large grid spaces allow for more detail, while 10–12 smaller grid spaces can help you focus on many, quickly generated ideas.

Idea generation within a grid provides structure that frees you to focus on creating new ideas.

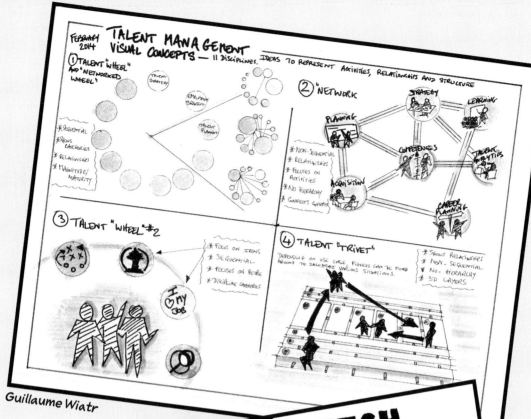

Guillaume Wiatr

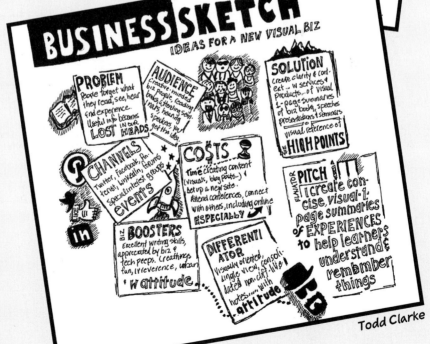

Todd Clarke

RADIAL FORMAT

The radial format works well with a single, central idea with information surrounding the hub. You can explore concepts in the space around the central hub.

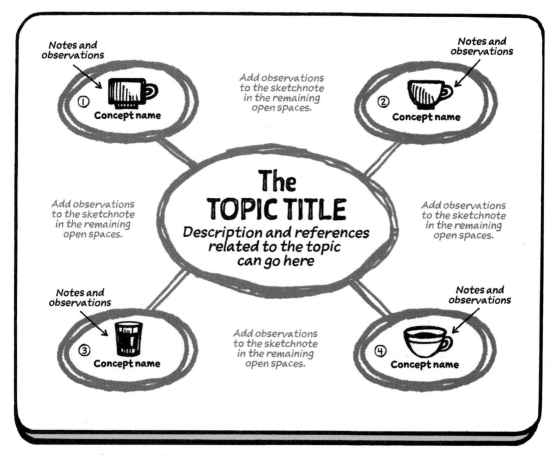

Place the main idea, topic, and reference notes in the central hub. Add notes, drawings, and icons in spaces around the central hub.

Working from the center outward frees you to capture and explore ideas in any order you like.

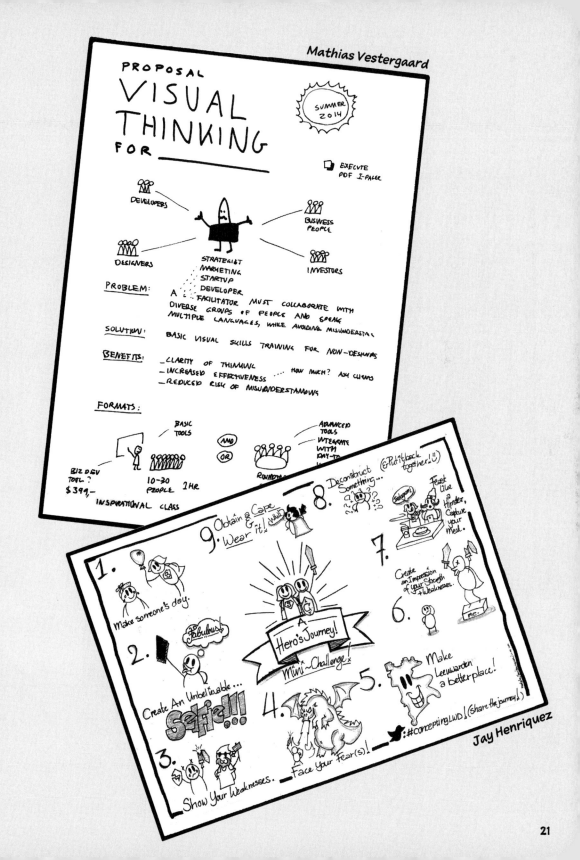

FREEFORM FORMAT
The freeform format offers more space for early-stage exploration where you need complete flexibility to play with ideas.

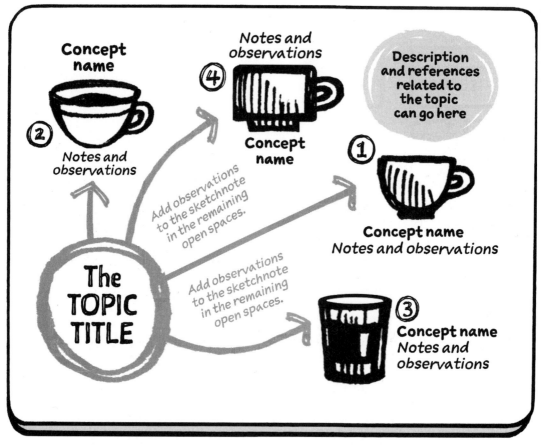

Position the main topic, reference notes, and your idea explorations in any pattern you'd like.

The freeform format allows you to place idea elements anywhere on the page for the ultimate in flexibility.

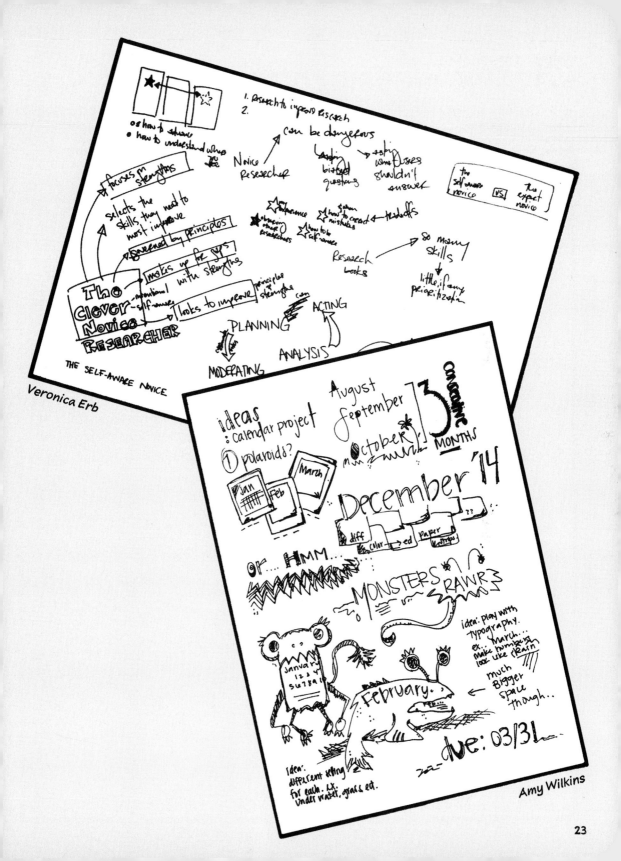

Veronica Erb

Amy Wilkins

USING THE GRID FORMAT

Use the grid format to generate ideas for a neighborhood lemonade stand. Brainstorm ideas on locations, cost of materials, pricing, stand design, and operating hours. Compare the feel and effectiveness of the three format styles, and the difference between the ideas you generate.

USING THE RADIAL FORMAT

Now use the radial format to generate ideas for a neighborhood lemonade stand using the same criteria as you used with the grid format. Observe how the radial format alters your approach and the ideas you generate.

W USING THE FREEFORM FORMAT

Finally, use the freeform format to generate ideas for a neighborhood lemonade stand using the same criteria as you used with the grid and radial formats. How are the results different from the other formats?

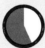

CHALLENGE 2.1

SKETCHNOTE TREE HOUSE IDEAS (PART 1)

Using a 4-panel grid format, sketchnote four different ideas for building a tree house (or another project if you like) in rough form. Make use of a 25-minute sprint with a 5-minute break, numbering your ideas and using the icon library.

TIMEBOX: **25min** Work session **5min** Review progress ↻ **Repeat**

QUESTIONS

How did it feel to generate those four ideas for the project in a limited timeframe? Was it easy or difficult to stay loose?

CHALLENGE 2.2

SKETCHNOTE TREEHOUSE IDEAS (PART 2)

Choose the best of the four rough ideas and create a final sketchnote with more detail and tighter drawings.

For this task use the radial format. Draw the chosen idea in the center hub, with notes, icons, and detail drawings around the hub in a radial fashion.

QUESTIONS

How did it feel to process your rough sketchnote ideas and convert them into a more final edition? Did you add or remove anything as you processed your winning idea?

27

USING ICONS
for IDEA Generation

Icons can help you tag ideas as you work for quicker access later. Once you embed icons in your sketchnotes, scanning through your notes for certain tags becomes much easier.

Creating your own library of icons specific to your work, industry, or area of focus is a great way to tag idea generation that better fits the way you think and work.

TIP CREATE AN ICON LIBRARY FOR IDEA GENERATION

With a collection of icons at your disposal, you can tag your sketchnote with icons as you work. Later you can scan for the icons as you process your work in your idea generation session.

START ROUGH, THEN REFINE

It's OK to start rough and work your way to intermediate and then final refined icons. Here's an example showing the three levels of icon quality:

Rough
Create a loose first draft to capture the concept quickly.

Intermediate
Add a bit more detail once you've got a good icon concept.

Final
Refine the details, and finalize the icon for your library.

IDEA GENERATION SAMPLES

Here's a selection of handy icons you can use in idea generation sessions:

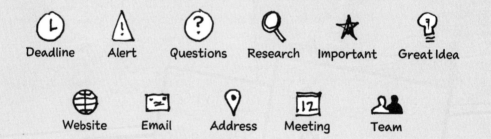

Deadline Alert Questions Research Important Great Idea

Website Email Address Meeting Team

INDUSTRY-SPECIFIC ICONS

Creating your own collection of icons specific to your work, industry, or area of focus is a great way to tag ideas that better fit the way you think and work. Here are icons from education, law, and business:

Education Law Business

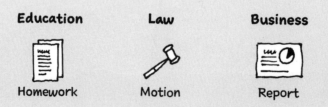

Homework Motion Report

W ICONS FOR EDUCATION

In the grid below, use squares, circles, triangles, lines, and dots to create icons for each word related to education. Skip ahead if you get stuck. The last row is blank so you can create your own icons.

WRITING	THINKING	TEST	SCHOOL
ERASER	CHALK	DESK	BOOK
STUDENT	TEACHER	WORKGROUP	ASSIGNMENT
RESEARCH	MATH	ENGLISH	HISTORY

ICONS FOR LAW

In the grid below, use squares, circles, triangles, lines, and dots to create icons for each word related to law. Skip ahead if you get stuck.
The last row is blank so you can create your own icons.

JURY	COURT	SUBPOENA	PRECEDENT
JUDGE	WITNESS	DEFENDANT	EYES ONLY
ORDER	CONFIDENTIAL	ROLL CALL	PLAINTIFF
LAWSUIT	CASE	CODE	CONTEMPT

ICONS FOR BUSINESS

In the grid below, use squares, circles, triangles, lines, and dots to create icons for each word related to business. Skip ahead if you get stuck. The last row is blank so you can create your own icons.

BUSINESS MODEL	BUSINESS PLAN	STOCK	LAPTOP
SERVER	OPPORTUNITY COST	CONTRACTOR	CREDIT
INVOICE	CHECK	EQUITY	PRICING
GROWTH	ASSETS	PAYMENT	INCOME

Don Pollitt

GENERATING IDEA SKETCHNOTES TO HELP SOLVE PROBLEMS

Don is a network systems engineer and IT consultant who is hired to solve tough technical problems for companies and schools. He uses sketchnotes to generate ideas that help solve those problems.

Using text, lettering, drawings, icons, and separators, Don creates a sketchnote that captures raw, unscreened and unfiltered thoughts as they occur. This process helps him find unique and innovative solutions because ideas are caught on paper before his mental filters can strain them out.

Don's idea generation process starts with his pocket Moleskine, a pen, and a timer set for 10 or 15 minutes. He creates a short title that defines the issue at the top of the first page. Then he starts the timer and captures whatever comes to mind as he thinks about the issue. Don uses a freeform format because it lets him capture ideas in a less structured way.

When the timer rings, he reviews the sketchnote to see if any insights jump out. Sometimes he'll create a refined sketchnote from one or more of the insights. Don values this ideation process because it has provided effective solutions to the challenges he faces in his work and life.

"With a pen and a pocket Moleskine, I'm more creative, and my work is more enjoyable. My sketchnotes are not works of art, but they've helped me become a more creative and timely problem solver."

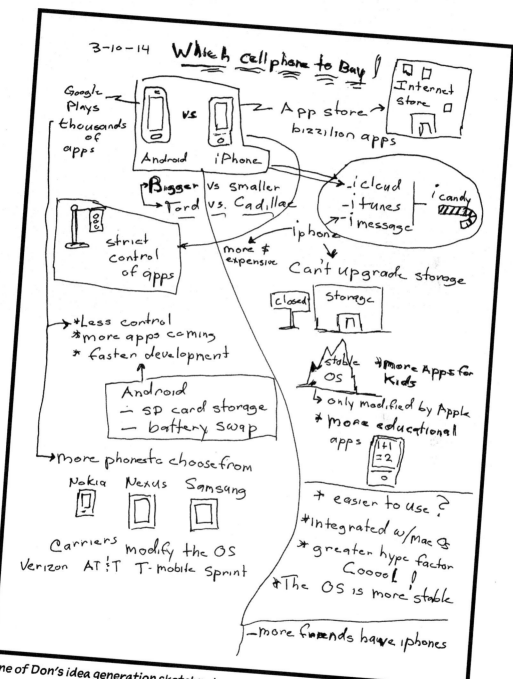

3-10-14 **Which Cellphone to Buy!**

Google Plays
thousands of apps

vs

Android iPhone

App store → Internet Store
bizzilion apps

- icloud
- itunes
- imessage
i candy

Bigger vs Smaller
Tord vs. Cadillac

strict control of apps

more $ expensive

iphone

Can't upgrade storage

closed | Storage

*Less control
*more apps coming
* fasten development

stable OS
*more Apps for Kids
→ only modified by Apple
* more educational apps
1+1 =2 0

Android
- SD card storage
- battery swap

more phones to choose from

Nokia Nexus Samsung

Carriers modify the OS
Verizon AT$T T-mobile Sprint

* easier to use ?
*Integrated w/Mac
* greater hype factor
Cooool !
*The OS is more stable

—more friends have iphones

One of Don's idea generation sketchnotes

BUILD AN ICON LIBRARY REFERENCE BOOK

In a new notebook or in the back of an existing notebook, keep a running list of concepts related to your field to be later converted to icons. As you encounter new terms, add them to the list.

At the end of the week, set aside 15 to 30 minutes to read through your list and convert as many concepts to icons as you can.

You can use another section of your notebook to keep the icons. Don't be afraid to explore multiple ideas for each concept until you get just the right one captured for daily use.

If you see icons other people are using, feel free to steal them for your icon library. A good icon library is a ready reference in idea generation sketchnoting sessions.

CONCEPTS FOR ICONS

√ Deadline
√ Alert
√ Question
√ Search
√ Important
√ Idea
√ Website
√ Email Address
√ Physical Address
√ Appointment
√ Team
 Investment
 Collaboration
 B-Roll
 Wage Scale
 Bluetooth

ICON LIBRARY

Deadline
Alert
Question
Search
Important
Idea
Website
Email Address
Physical Address
Appointment
Team

RECAP

→ Observe your thinking, identify new ideas, and then use sketchnotes to capture those ideas.

→ Keep your sketchnotes quick, loose, and even a little bit crazy. *Crazy often leads to great ideas.*

→ Timebox your idea generation. Deadlines help keep your mind loose and your hand moving.

→ When visual and verbal parts of your brain work together, you can create a richly detailed visual map of your ideas and thoughts.

→ Explore ideas with the three formats—Grid, Radial, and Freeform—or create your own format.

→ Build an icon library of concepts you use often.

→ Keep a running list of ideas you'd like to convert to icons, and then create icons during downtime.

→ Steal icons from other people for your own library.

★ NEXT: SKETCHNOTE IDEA MAPPING

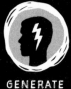

GENERATE

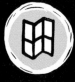

MAP

PLAN

DOCUMENT

Chapter 3

SKETCHNOTE IDEA MAPPING

Sketchnotes don't have to be the end result of visual thinking. You can use sketchnoting as a valuable step in the middle of a project to analyze and better understand information.

What ARE SKETCHNOTE IDEA MAPS?

Sketchnote idea maps are a means to gather research material into a visual document using sketchnoting elements like drawings, lettering, icons, connectors, dividers, and text.

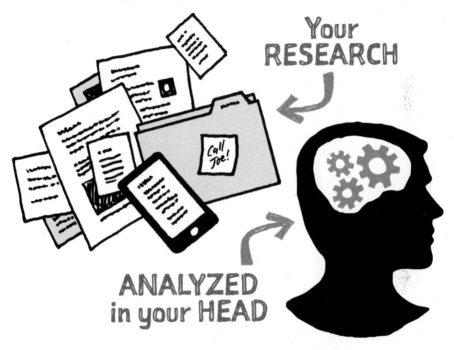

Your **RESEARCH**

ANALYZED in your HEAD

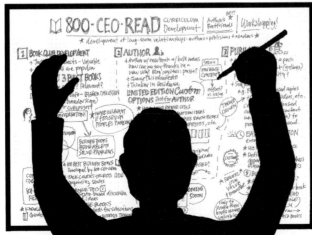

MAPPED as a VISUAL DOCUMENT

INFORMATION mapped at both a high level and in fine detail can offer a view of the overall structure, the relationships between ideas, and the granular details in a single document.

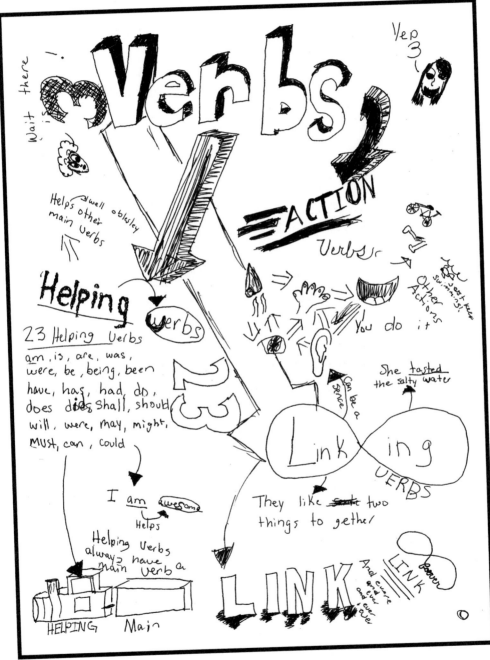

SkylerTiffin

the BENEFITS OF MAPPING
IDEA SKETCHNOTES

Sketchnote idea mapping offers a variety of benefits:

 EMBED DETAILS into your memory as you process, analyze, and draw information by hand.

 GIVE A UNIFIED perspective on information versus looking at bits and pieces of information stored in various locations.

 VIEW INFORMATION on different levels: zoom out for the big picture, zoom in for more detail.

 BRIDGE THE GAP between research and the end result. It's an in-between period of synthesis, exploration, and play.

 BYPASS WRITER'S BLOCK because you're working in a different way. A visual map frees you to work with information while diminishing the pressure of delivering a final product.

HOW TO CREATE AN IDEA MAP

The next few pages show my own process for creating sketchnote idea maps. Adapt and improve the process to fit your own.

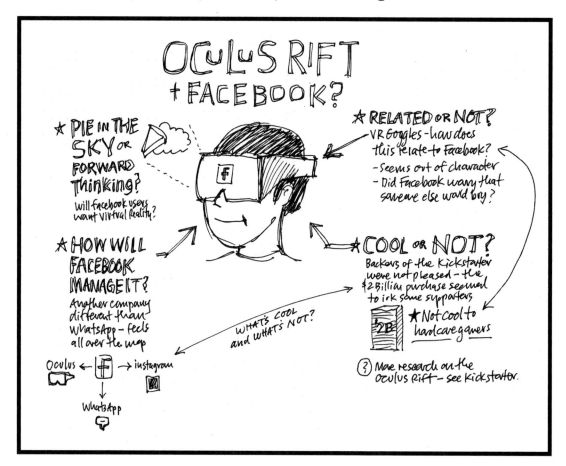

★ **PROGRESS, NOT PERFECTION** ★

Just start somewhere and let the information build up as you work.

★ **MESSY SKETCHNOTES ARE OKAY** ★

If the first rough idea map is too messy, creating a cleaned-up idea map gives you a chance to further refine your thinking.

IDEA MAP STEPS

Follow these seven steps to create your own idea map, making your own adjustments to fit your style and needs.

1 GATHER YOUR RESEARCH

Your information is your guide for processing and analysis. Printing documents can make the process more tangible, but using a laptop or tablet is just fine too.

CHOOSE A MAPPING SURFACE

You can build your map on a large poster sheet, a piece of paper, a sketchbook page, a whiteboard, or even a drawing app on your iPad. Bigger is better if you have lots of ideas to map. Smaller can help you focus your thinking.

Moleskine

Paper roll

Copy paper

Whiteboard

Pocket notes

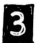 # START WITH THE TOPIC

If you have a main theme or topic, start by writing it at the
top of the map on the left, right, or center in a larger
headline lettering.

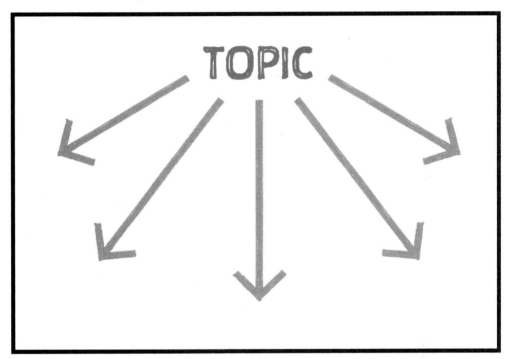

Topic at top-center

Topic at top-left

Topic at top-right

4 MAP OUT YOUR IDEAS

Read through your research materials, seeking out key ideas. Capture those ideas on the map using text and drawings, keeping them as concise as possible.

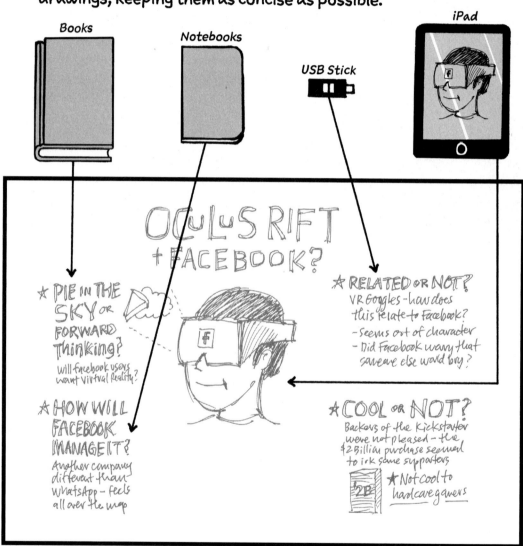

Books

Notebooks

USB Stick

iPad

OCuLuS RIFT
+ FACEBOOK?

★ PIE IN THE SKY OR FORWARD Thinking?
Will facebook users want Virtual Reality?

★ HOW WILL FACEBOOK MANAGE IT?
Another company different than WhatsApp — feels all over the map

★ RELATED OR NOT?
VR Goggles - how does this relate to Facebook?
- Seems out of character
- Did Facebook worry that someone else would buy?

★ COOL OR NOT?
Backers of the Kickstarter were not pleased - the $2 Billion purchase seemed to irk some supporters
★ Not cool to hardcore gamers

Leave margin space around each key item so you can add new details as you work, or append your sketchnote later.

5 REVIEW & CONNECT IDEAS

With your first pass through your research materials complete, review the map and look for connections. Add new ideas to the map and use connectors and arrows to tie ideas together.

The initial sketchnote

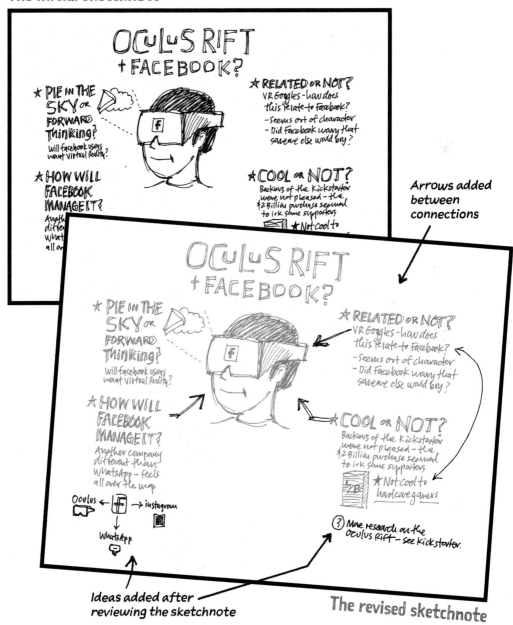

Arrows added between connections

Ideas added after reviewing the sketchnote

The revised sketchnote

6 SPOT & MARK PATTERNS

Look for repetitive ideas when reviewing your map. Note repeating patterns on the map or in a dedicated area using icons and comments.

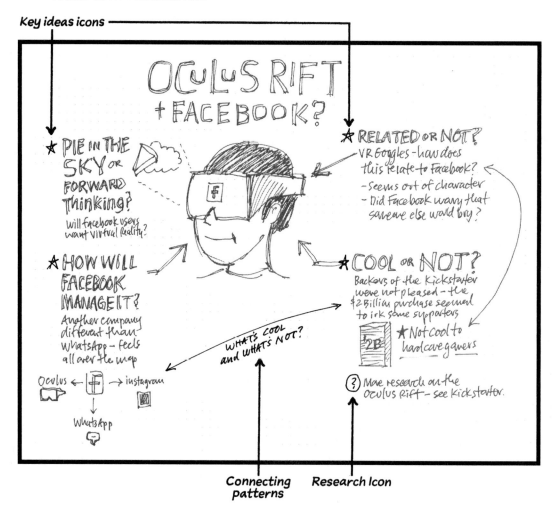

Key ideas icons

OCULUS RIFT
+ FACEBOOK?

★ PIE IN THE SKY OR FORWARD Thinking?
Will facebook users want virtual reality?

★ RELATED OR NOT?
- VR Googles - how does this relate to Facebook?
- Seems out of character
- Did Facebook worry that someone else would buy?

★ HOW WILL FACEBOOK MANAGE IT?
Another company different than whatsApp - feels all over the map

Oculus ← f → instagram
 ↓
 WhatsApp

WHAT'S COOL and WHAT'S NOT?

★ COOL OR NOT?
Backers of the Kickstarter were not pleased - the $2 Billion purchase seemed to irk some supporters
★ Not cool to hardcore gamers

2B

? More research on the Oculus Rift - see Kickstarter.

Connecting patterns Research Icon

7 CREATE A NEW MAP

If your idea map is messy and is hard to read, that's OK. Sketchnote maps are thinking tools. You can create a new map by reviewing and transferring ideas: add, remove, move, and tweak details as you go.

C MAKE A LARGE SKETCHNOTE IDEA MAP

Select a topic of your choice and gather research (articles, images, etc.).

On a large sheet of paper, write the topic at the top of the page and begin converting key ideas into an idea map using text, images, and icons.

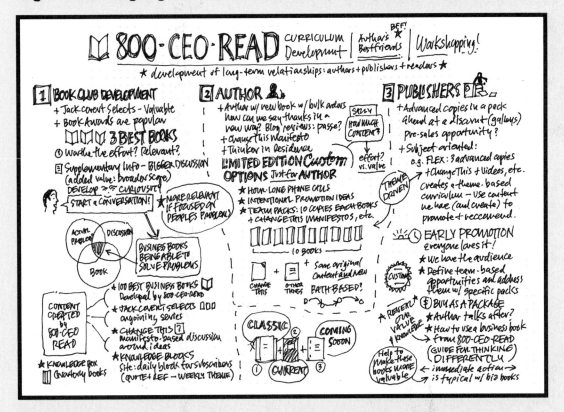

Review your rough sketchnote idea map looking for connections. Mark the connections with lines, arrows, and connectors.

Look for patterns, documenting them in the remaining space at the base of the map, and connecting them with ideas above using icons. If it's too messy, re-create the idea map to clean it up.

QUESTIONS

How did your perspective of the topic change after mapping?
What connections and patterns emerged after your review?

PRACTICAL USES

You can apply idea map sketchnotes to many areas of work and personal life. Here are a few ways they can be useful:

★WRITING

Creating a visual map of the ideas you're working with can aid in the process of writing an article, book, or other material. Research and reference materials are typically spread out across pages or in computer files. Sometimes ideas are lost within large quantities of text. Converting information into a visual idea map lets you see how these varied elements interconnect.

C. WESS DANIELS, a PhD candidate with writer's block, decided to create a sketchnote map of his dissertation themes. By mapping out his research, he was able to see the key themes of his writing from a different perspective.

THE INTERMEDIATE STEP OF MAPPING HELPED RELIEVE THE PRESSURE OF WRITING, GIVING HIM A WAY TO SNEAK PAST HIS MENTAL BLOCK TO FINISH HIS DISSERTATION.

C. Wess Daniels

THIAGO ESSER, Interaction/UX designer, uses sketchnotes to remind himself that a developer thinks quite differently than the user.

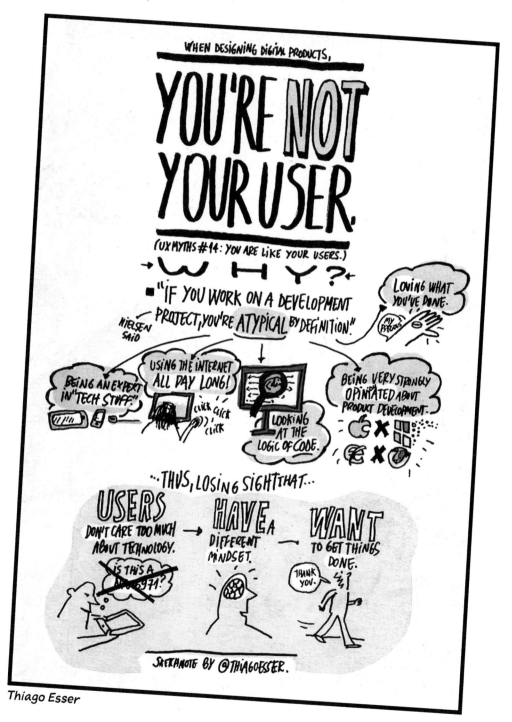

Thiago Esser

CLAUDIA CERANTOLA from Brazil uses sketchnotes to write letters that are more compelling than regular text-only letters. Her hand-drawn images add a human touch to her *sketchletters,* and because they're fun to create, she is excited to make them.

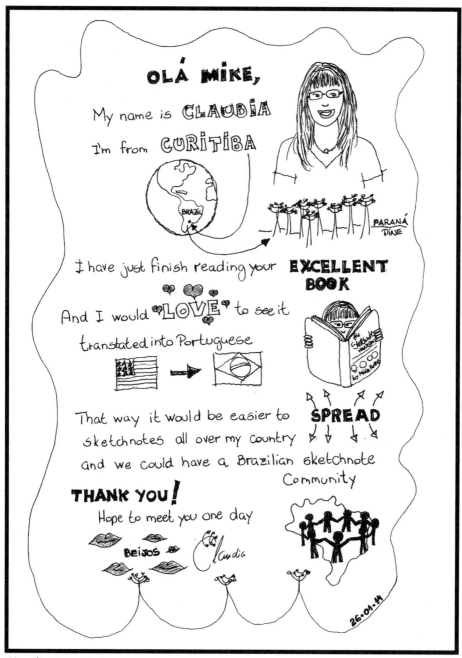

Claudia Cerantola

C WRITE A SKETCHNOTE LETTER

Create a letter for a friend or family member using the sketchnote idea mapping techniques with text, lettering, and images. Mail your sketchnote letter.

QUESTIONS

How did it feel to write a sketchnote letter?
What was the reaction of the recipient?
What would you do differently next time?

★PRESENTATIONS

Diagramming your presentation with an idea map on index cards or sticky notes is helpful in the early stages of presentation preparation.

On the first pass, get your main ideas down so you can see the flow.

 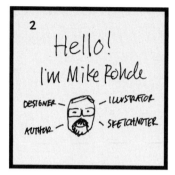 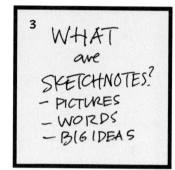

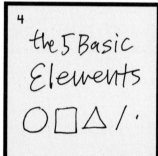

On your second pass, realign elements to improve the presentation's flow.

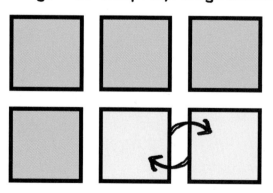

Index cards and sticky notes work great for building presentations because you have the flexibility to move cards or notes around to get a perfect flow.

You can use each card or note to present from or as a handy reference for building out your final slide deck.

DEREK GRAHAM uses sketchnotes to prepare and give presentations. Sketchnotes help him reduce his anxiety because he can see the entire story at a glance. His level of comfort with the story frees him to ad lib as he presents his ideas to a group.

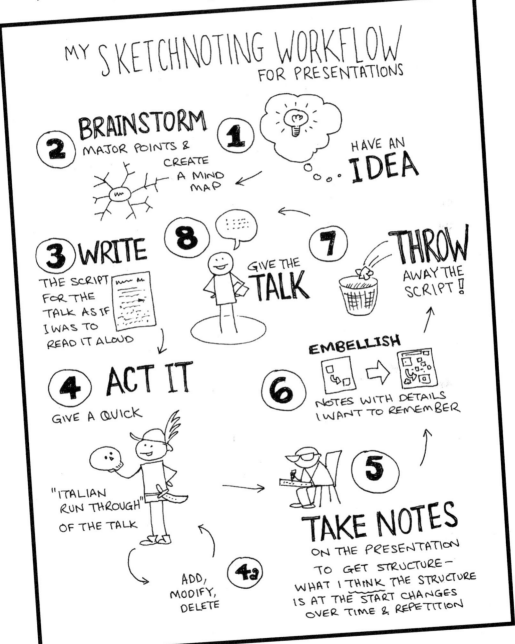

Derek Graham

MAP OUT A PRESENTATION

Using sketchnotes, capture ideas for a presentation on a series of index cards or sticky notes. Initially, focus on capturing the key elements of the presentation without regard to the order.

Once your ideas are captured, place the cards or notes on a table and reorder them into a logical flow. You can explore different combinations.

QUESTIONS

Was it easy or difficult to randomly place ideas on index cards or sticky notes without concerning yourself with a specific order?

Did using index cards or sticky notes improve your ability to adjust ideas for optimal flow?

★LANGUAGE LEARNING

Connecting words and phrases in your own language with words and phrases in a new language can be a good use for a sketchnote idea map.

You can make flash cards with index cards by adding a word and drawing for one language on the front of the card, and the same for the new language on the back of the card.

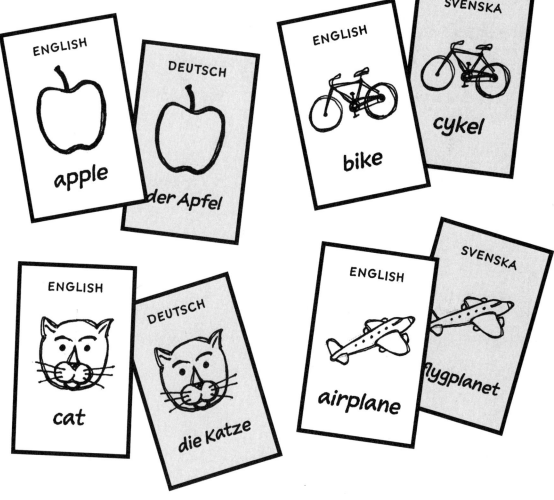

The process of creating flash cards will embed words and images more deeply in your memory.

AGA AND PIOTR POZNAŃSKI of Poland use sketchnote flash cards to improve their language skills. Here are samples of the flash cards they've created for Japanese and Italian:

Aga and Piotr Poznański

C MAKE SKETCHNOTE FLASH CARDS

Take ten index cards and on each card write out one common English word with a drawing of the word above or below it.

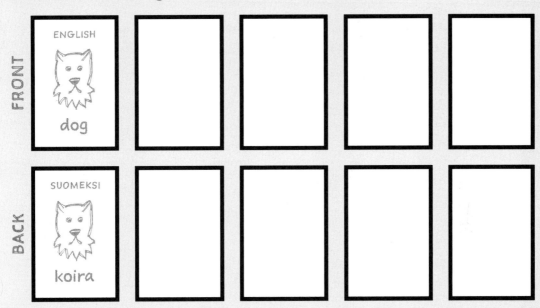

Flip each card over and do the same but with the equivalent foreign language word.

Memorize the ten foreign words and images on the flash cards for 2 minutes each (20 minutes total).

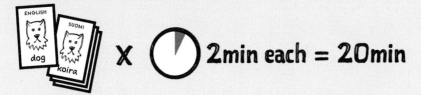

X ⏱ 2min each = 20min

Have someone test your memory using your cards.

QUESTIONS
How many words were you able to remember?
Did your creation of these cards help you remember the words better?
How many words do you recall when tested one week later?

W BUILD A LANGUAGE ICON LIBRARY

In the grid below, create flash cards for both English and German words.
The last row is blank so you can create your own icons.

English	German	English	German
CAR	DAS AUTO	COFFEE	DER KAFFEE
TRAIN	DER ZUG	BOOK	DAS BUCH
LIGHTBULB	DIE GLÜHBIRNE	BIKE	DAS FAHRRAD
CAMERA	DIE KAMERA	FISH	DER FISCH

English	German	English	German
CAT	DIE KATZE	APPLE	DER APFEL
SHOES	DER SCHUHE	PENCIL	DER BLEISTIFT
EARTH	DIE ERDE	TREE	DER BAUM
CLOCK	DIE UHR	MOUNTAIN	DER BERG

Jackie Pomeroy-Tso

SKETCHNOTE MAPPING HELPED BYPASS WRITER'S BLOCK

Jackie Pomeroy-Tso, a 4th grade student, solved her writer's block by creating a sketchnote idea map while working on a school project.

Her assignment was to write a report about one of the missions of California including the goods they made and traded. The teacher required a new format for the report that Jackie wasn't familiar with. She also had a hard time describing the actions that people in the mission used to make their goods. Both of these issues gave her writer's block.

Jackie's references included a teacher-provided sheet on the mission, articles and images found online, and notes and photos from a day trip to the mission. Having just read *The Sketchnote Handbook*, she had an idea: Why not map out her research in a sketchnote? So she did, using it as a means to keep working despite her writer's block.

The sketchnote map let her see the research from a different perspective. It gave her a clearer direction for writing her report in a new format.

And after mapping out her research, Jackie was able to see the whole picture, verbally describe the process, and finish her report.

"Mapping my missions research as a sketchnote was a fun way to see my report in a different way."

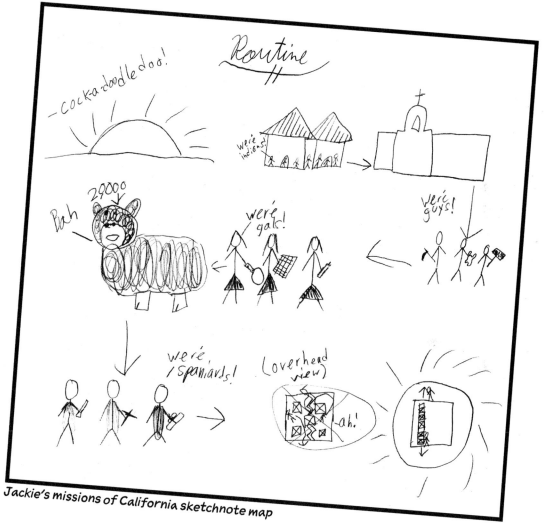

Jackie's missions of California sketchnote map

IDEA MAP TOOLS

Here are two alternative tools you can use in your idea mapping practice:

INDEX CARDS

Use index cards to map out ideas. As you process information, capture each key idea on a single card until you create a stack. Organize the cards on a table, ordering them by ideas, playing with placement.

Capture the structure on the table with a camera, or transfer the cards to a single page of paper with tape or glue.

STICKY NOTES

Use sticky notes to map out ideas on a wall or a whiteboard. Organize and play with the notes until you settle on a structure.

Place your sticky notes on a board or in a sketchbook. For permanency, photograph them or convert them into a single sketchnote map on paper.

RECAP

→ Sketchnote maps are a valuable in-between step that can offer better understanding.

→ Sketchnote maps offer both high-level and fine detail in a single document.

→ Sketchnote maps free you to work with information, diminishing the pressure to deliver a final product and helping to bypass writer's block.

→ Embed detail into your memory as you process, analyze, and draw information by hand.

→ Get a unified perspective on your information.

→ Don't worry about perfection! Start somewhere and let the information build up as you work.

→ Sketchnote maps are useful for writing, presentations, and language learning activities.

★ NEXT: SKETCHNOTE PLANNING

GENERATE

MAP

PLAN

DOCUMENT

Chapter 4

SKETCHNOTE PLANNING

Sketchnotes are well suited for planning.
Use them to plan ahead visually for projects like
simple task lists, family vacations,
work assignments, and more.

Planning _WITH_
SKETCHNOTES

Drawing out your plans is the first step along the path
of turning ideas into reality.

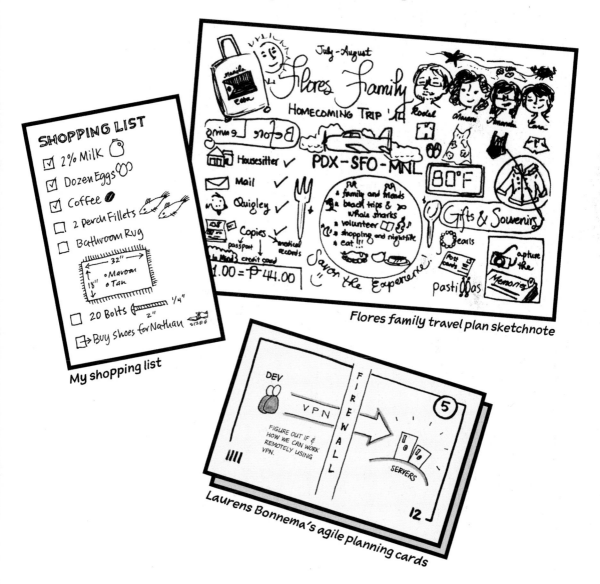

My shopping list

Flores family travel plan sketchnote

Laurens Bonnema's agile planning cards

THE ITERATIVE NATURE
OF SKETCHNOTING GIVES YOU

flexibility:

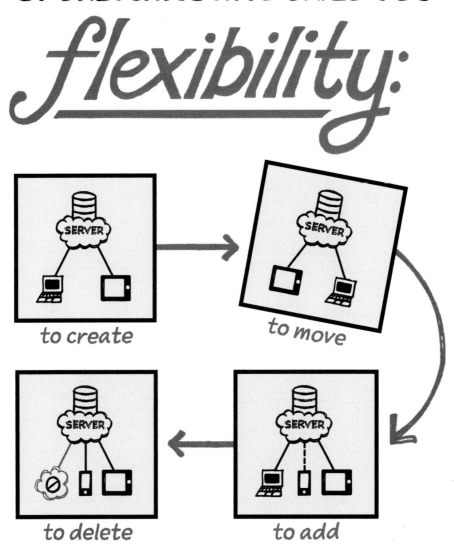

to create

to move

to delete

to add

AND TO REFINE YOUR IDEAS
AS PLANS CHANGE.

the BENEFITS OF PLANNING
WITH SKETCHNOTES

Sketchnote idea mapping offers a variety of benefits:

 VISUALLY REPRESENT the elements of a project: tasks, dates, people, discussions, and reference information.

 GET A DIFFERENT PERSPECTIVE on your plans by adding visual detail. Sketchnote plans can reveal patterns you may not see otherwise.

 ZOOM IN AND OUT of the overview and details of a project in the same planning sketchnote.

 EMBED PROJECT DETAILS in your memory using visual elements like icons, typography, drawings, and containers as you create your plans.

 USE FOR TEAMS because lots of data are packed into visual images that are shared between team members or posted for team review.

PRACTICAL USES

Here are some ways to use sketchnotes as a planning tool:

★TASK LISTS

Using visuals to amplify your tasks helps connect you with what you have to get done. Try using some of these action icons to visualize your tasks:

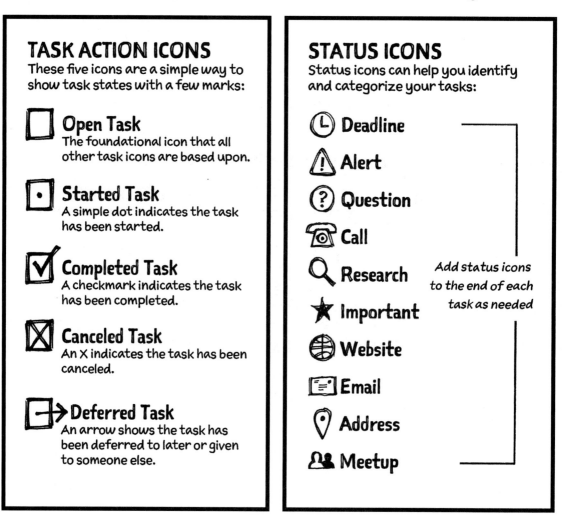

TASK ACTION ICONS

These five icons are a simple way to show task states with a few marks:

Open Task
The foundational icon that all other task icons are based upon.

Started Task
A simple dot indicates the task has been started.

Completed Task
A checkmark indicates the task has been completed.

Canceled Task
An X indicates the task has been canceled.

Deferred Task
An arrow shows the task has been deferred to later or given to someone else.

STATUS ICONS

Status icons can help you identify and categorize your tasks:

Deadline

Alert

Question

Call

Research

Important

Website

Email

Address

Meetup

Add status icons to the end of each task as needed

Icons are an effective way to represent all the things you have to get done.

ATTORNEY DAVID SPARKS uses sketchnotes to plan his court hearings. He creates check boxes for those present, has dedicated space for the hearing and ruling details, and a check box if he has to notify all parties. The left sidebar is reserved for adding notes during or after the hearing.

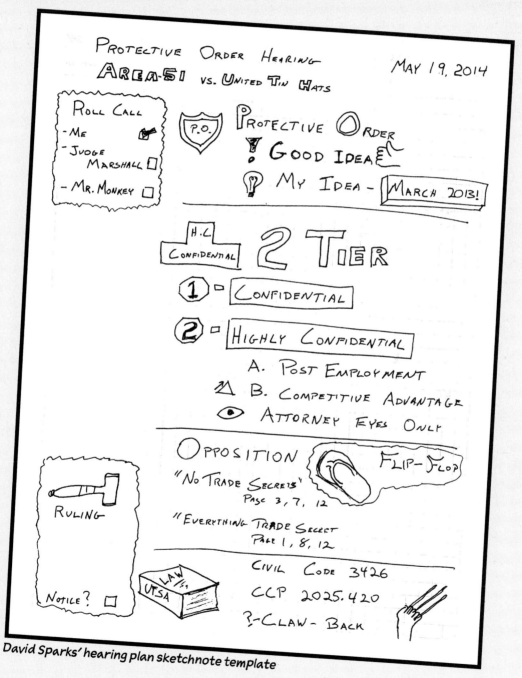

David Sparks' hearing plan sketchnote template

TIP ADD DIAGRAMS TO YOUR TASK LISTS

You can embed drawings with detailed notes in your task list for easy reference. For instance, you could draw a garden plan before shopping for plants, or diagram your living room before buying a new sofa.

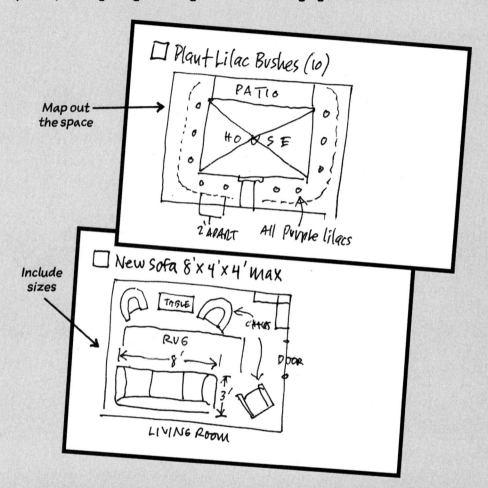

Map out the space

Include sizes

Combining tasks with hand-drawn references eliminates guesswork once you're out completing your tasks.

Working with these simple drawings is a good start to get you thinking in a more visual manner.

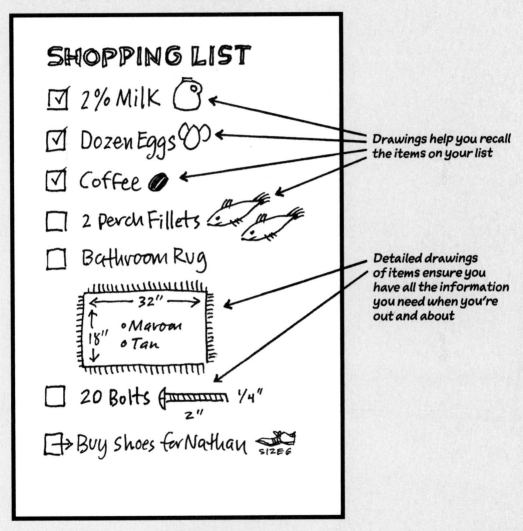

C CREATE A SKETCHNOTE TASK LIST

Using the check box system and other task icons provided in this chapter, create a task list for your day, week, or weekend. Where appropriate, include diagrams with task details in your list for reference.

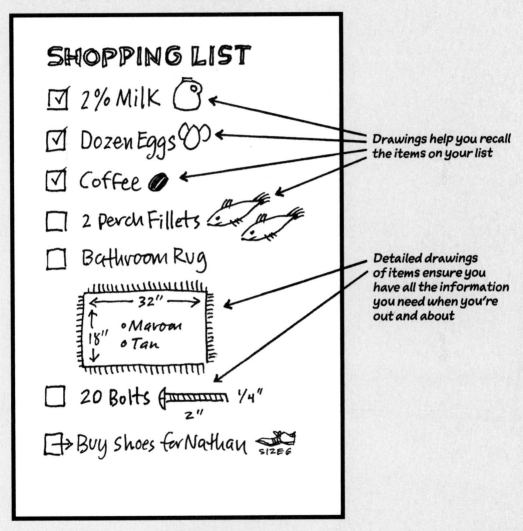

QUESTIONS

How did the sketchnoted task list work? Did you remember more about each task by adding visuals, like an icon or a drawing? If you added a detailed diagram, did it help you complete the task more effectively?

★ PLANNING YOUR FUTURE

You can use sketchnotes to review your past and plan your future.
Sacha Chua uses sketchnotes to project her life five years in the future
as part of an Alphachimp course she participated in.

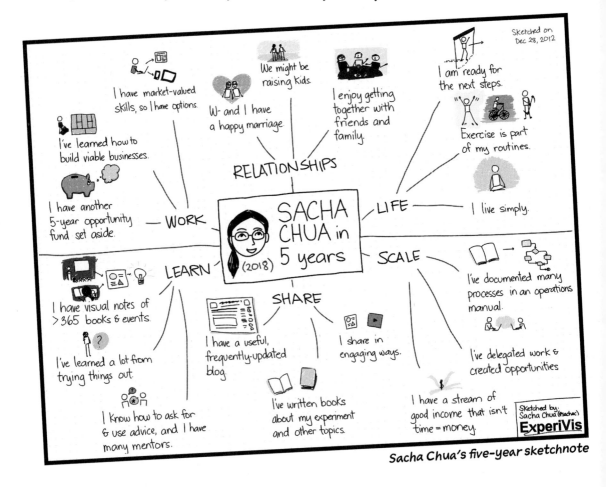

Sacha Chua's five-year sketchnote

*With her name, portrait, and a future year
in a central hub, Sacha creates clear declarative
statements of her five-year
future self around it.*

IVAN SEYMUS creates his own five-year plan sketchnote:

Ivan Seymus' five-year sketchnote

CREATE A FIVE-YEAR SKETCHNOTE PLAN

Think about your goals five years in the future, and then roughly sketchnote those ideas on a sheet of paper.

Place your name and a date five years in the future at the center of the page, with attributes surrounding your name including items like work, life, family, relationships, travel, and any other important items in your life of the future.

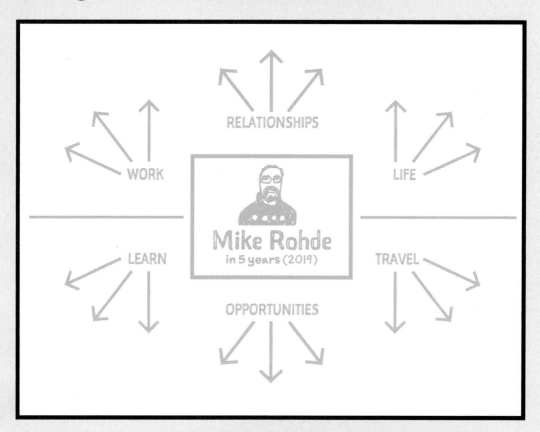

Stay loose, using drawings, icons, and bold lettering to emphasize written text. Describe yourself as if you are already living out the attributes you wish to achieve five years in the future.

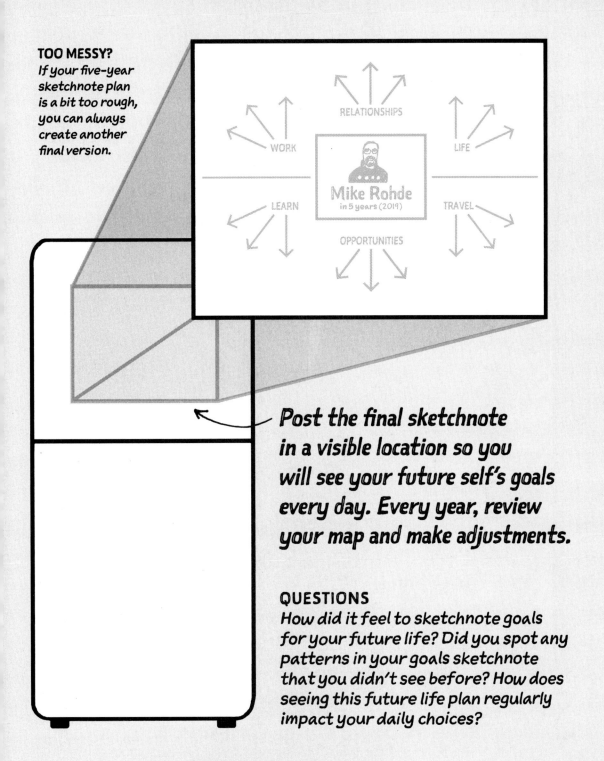

TOO MESSY?
If your five-year sketchnote plan is a bit too rough, you can always create another final version.

RELATIONSHIPS

WORK

LIFE

Mike Rohde
in 5 years (2019)

LEARN

TRAVEL

OPPORTUNITIES

Post the final sketchnote in a visible location so you will see your future self's goals every day. Every year, review your map and make adjustments.

QUESTIONS
How did it feel to sketchnote goals for your future life? Did you spot any patterns in your goals sketchnote that you didn't see before? How does seeing this future life plan regularly impact your daily choices?

★ PLANNING TRIPS

Sketchnotes are a fun way to do your travel planning with visual flair.

HOW TO CREATE A TRAVEL PLAN SKETCHNOTE

Place the destination at the top of the page, filling in the remaining page with flight details, hotel location, reservation details, ground travel information, maps, and a list of the sights you'd like to see.

| TICKETS | FLIGHT | TAXI | BUS | TRAIN | HOTEL |

Use icons to identify each element, bold type to break out key sections, dividers to break up sections, and arrows to connect key information.

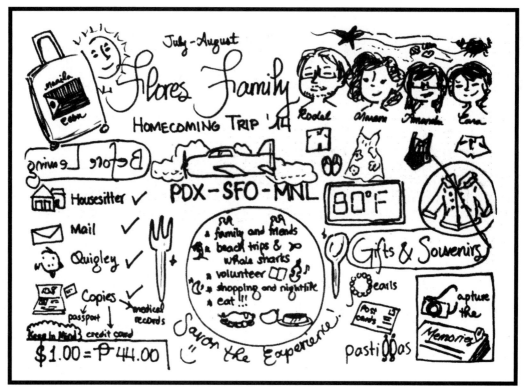

Flores family travel plan sketchnote

Marem Flores uses sketchnoting as a visual tool for planning family vacations. Her entire family discusses vacation details, and then together they build a collaborative sketchnote of their upcoming trip.

Review your sketchnote travel plan before you depart each day as a quick refresher. Use it to remember small details and planned activities that you might otherwise forget to include.

→ Now that you've seen how to sketchnote your travel plans before you leave, be sure to read Chapter 6 for ideas on sketchnoting trip experiences during your travels.

TIP ## TAKE A PHOTO OF YOUR TRAVEL PLAN

Once you've completed your sketchnote travel plan, take a photo with your smartphone or digital camera. You can use this image as a handy reference for yourself, or to share with family members or co-workers, keeping everyone on the same page.

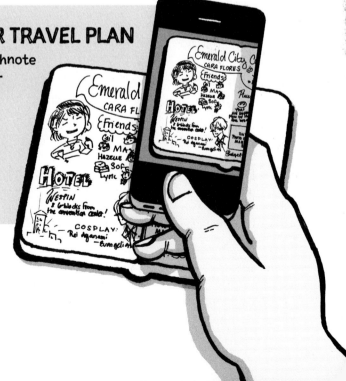

DIAGRAM OF A SKETCHNOTE TRAVEL PLAN

Here's a diagram of my travel sketchnote plan for SXSW Interactive 2015:

FLIGHTS
Cities, flight numbers, departures, and arrivals

LODGING
Address, price, location, and contact info

TRIP TITLE
Event, location, and date

WHERE TO EAT
Favorites or places to explore

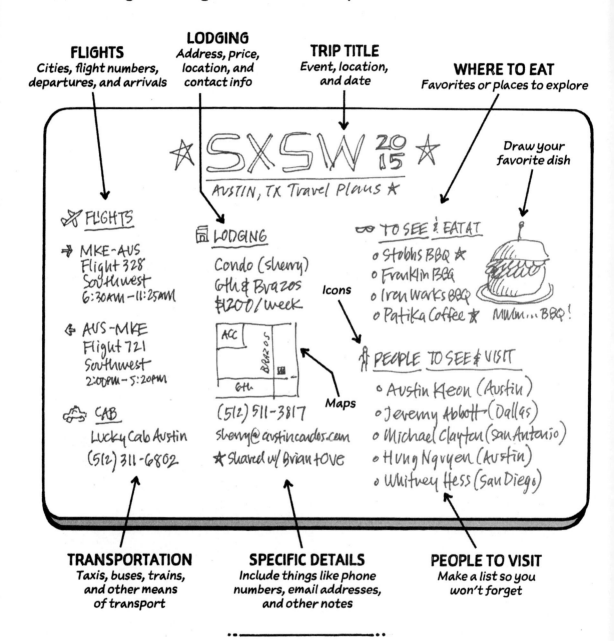

Draw your favorite dish

Icons

Maps

TRANSPORTATION
Taxis, buses, trains, and other means of transport

SPECIFIC DETAILS
Include things like phone numbers, email addresses, and other notes

PEOPLE TO VISIT
Make a list so you won't forget

Sketchnote travel plans help you see the big picture while providing the details you need for specific activities.

C CREATE A SKETCHNOTE TRAVEL PLAN

Before your next trip, take some time to gather the flight, hotel, city sights, maps, and any other relevant trip information.

Create a sketchnote map of these elements, starting with the title at the top of the page or in the center, and placing travel details around the title. If your map gets messy, create a final sketchnote.

When finished, review the plan before you travel. Take a photo of the map for yourself or to share with family members or colleagues.

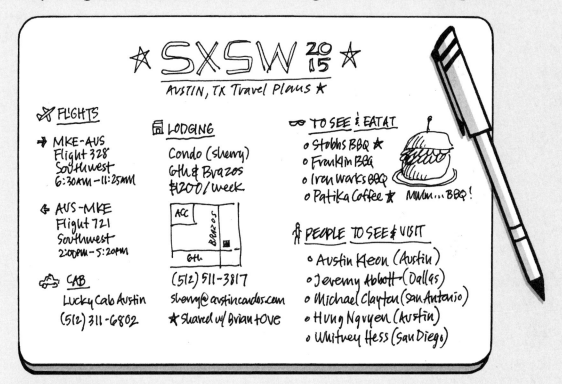

QUESTIONS

How did this visual travel plan work as a reference? Did you get a better overview of the trip plans through documenting them visually? Were you more aware of daily activities because of this sketchnote plan? If your family was on the trip, did it help them understand and communicate the trip's plans more effectively?

ICONS FOR TRAVEL

In the grid below, use squares, circles, triangles, lines, and dots to create icons for each word related to travel. Skip ahead if you get stuck.
The last row is blank so you can create your own icons.

RENTAL CAR	LUGGAGE	FAMILY TRUCKSTER	BACKPACK
TEMPERATURE	CURRENCY	FORECAST	PASSES
PASSPORT	SOUVENIR	DUTY-FREE	REST STOP
ARRIVAL	DEPARTURE	MOTEL	GASOLINE

★PROJECT PLANNING

Sketchnotes are useful for planning projects large or small.

HOW TO CREATE A PROJECT PLAN SKETCHNOTE

With the project's title and description at the top of a page, fill in the remaining space with project details.

Visually build the project's flow, documenting milestones, tasks, and personnel. Use drawings, hand-drawn type, and text to capture decision-maker details, roles, and tasks of each team member.

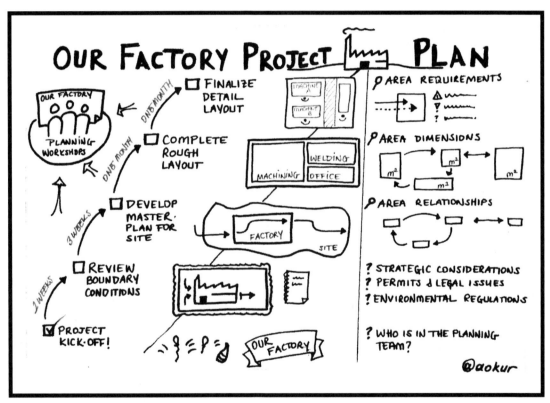

Aclan Okur's factory plan sketchnote

ACLAN OKUR is a consultant who plans complex factory construction projects. For his planning, Aclan uses sketchnotes because they're effective at bringing everyone together and helping projects go smoothly, and they're much more fun for everyone.

SKETCHNOTES AND AGILE PLANNING

Scrum is an agile methodology that offers an iterative, flexible way to manage projects using two-week sprints that include planning and daily check-ins to gauge progress, followed by a retrospective and a review to see what worked and what can be improved for the next sprint.

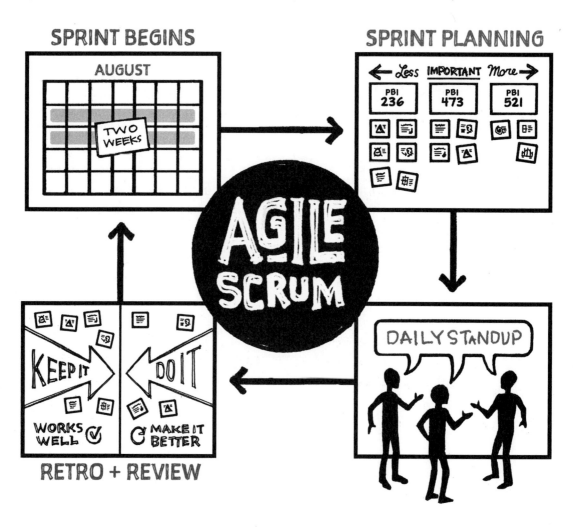

Sketchnotes are useful planning tools
that are well suited to the agile process.

AT THE START of an agile project, the team creates personas to describe users and how they may want to use a product being built.

Sketchnotes are a useful way to document a project's personas with bold lettering for user names, drawn user portraits, and text for the description with icons to highlight key elements. Use index cards to make your user story sketchnotes portable.

SKETCHNOTED PERSONA

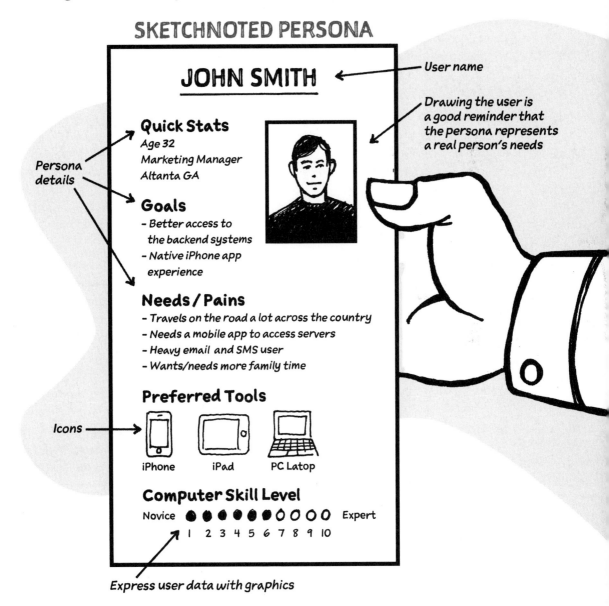

JOHN SMITH

User name

Drawing the user is a good reminder that the persona represents a real person's needs

Persona details

Quick Stats
Age 32
Marketing Manager
Altanta GA

Goals
- Better access to the backend systems
- Native iPhone app experience

Needs / Pains
- Travels on the road a lot across the country
- Needs a mobile app to access servers
- Heavy email and SMS user
- Wants/needs more family time

Preferred Tools

Icons

iPhone iPad PC Latop

Computer Skill Level
Novice ●●●●●●○○○○ Expert
 1 2 3 4 5 6 7 8 9 10

Express user data with graphics

YOU CAN USE SKETCHNOTES to document the team's sprint planning and sprint reviews. Teams can use common icons for recurring items or people, and bold type to emphasize issues and more.

SKETCHNOTED SPRINT PLAN

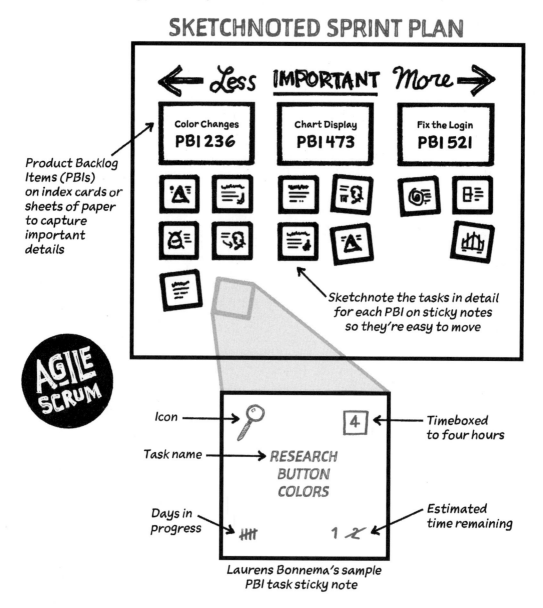

Product Backlog Items (PBIs) on index cards or sheets of paper to capture important details

Sketchnote the tasks in detail for each PBI on sticky notes so they're easy to move

Icon

Task name

Days in progress

Timeboxed to four hours

Estimated time remaining

Laurens Bonnema's sample PBI task sticky note

LAURENS BONNEMA, a Dutch agile scrum coach, uses sketchnotes for sprint planning, retrospectives, and reviews. Now his teams prefer the sketchnoted cards and notes, and even boast about them to other teams!

SKETCHNOTES can help you document what worked well in the last sprint, and prescribe steps that should be taken to correct what didn't work well to improve the next sprint. This process is called a *retrospective*.

SKETCHNOTED RETROSPECTIVE

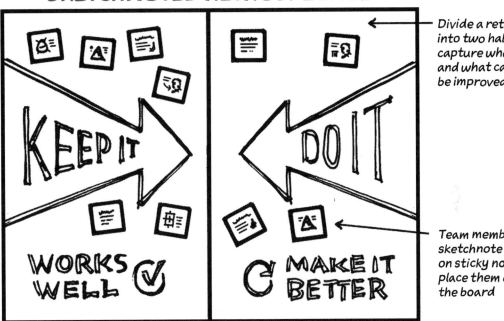

Divide a retrospective into two halves to capture what works and what can be improved

Team members sketchnote feedback on sticky notes and place them on the board

These are samples of Laurens' retrospective sketchnote index cards:

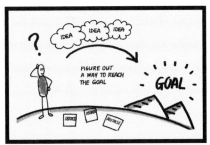

PHOTOGRAPH OR SCAN BOARDS YOU CREATE TO SHARE THEM WITH TEAMS AS A QUICK REFERENCE.

Julie Stitt

USING SKETCHNOTES TO CREATE LEARNING EXPERIENCES

Julie Stitt is an organizational cartographer, facilitator, and leadership coach from the Niagara Peninsula of Ontario, Canada.

She started sketchnoting to capture memorable notes from the seminars she attended. With a background in organizational development and training in graphic facilitation, sketchnoting was a natural fit for Julie.

Seeing how well sketchnoting worked for documenting seminars, Julie experimented with sketchnotes as a way to plan and develop curriculum and learning experiences for her clients.

Sketchnotes and workshop planning are a match made in heaven. They're a perfect way to visually document key information on just one or two pages.

At a glance, Julie and her clients can understand how workshop pieces fit together, determine the flow of the teaching, and see what's going to be covered in a workshop. Julie has found that sketches added to her workshop handouts and reference materials accelerate learning.

"Sketchnotes set a tone of collaboration, authenticity, and humanity. They encourage connections between me, my clients, and the subject we're studying."

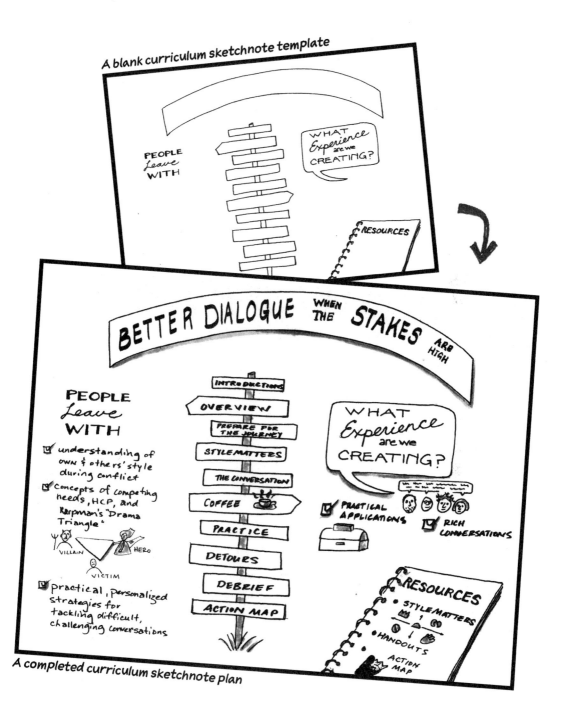

A blank curriculum sketchnote template

A completed curriculum sketchnote plan

ICONS FOR PLANNING

In the grid below, use squares, circles, triangles, lines, and dots to create icons for each word related to project planning. Skip ahead if you get stuck. The last row is blank so you can create your own icons.

DEADLINE	STAND-UP	APPOINTMENT	RESEARCH
SPRINT	REVIEW	PROBLEM	TIMEBOX
PROGRESS	BACKLOG	OBSTACLE	GOAL
PERSONA	RESOURCE	LEAD	SUCCESS

RECAP

→ Sketchnotes are a flexible way to visually plan projects for yourself or a team.

→ Drawing out your plans is the first step along the path of turning ideas into reality.

→ The iterative nature of sketchnoting gives you flexibility: to create, move, add, or delete ideas, and to refine your ideas as plans change.

→ Sketchnoting your plans provides a different perspective you may not see otherwise.

→ Sketchnotes help teams because visuals can convey lots of information and are easily shared.

→ Using visuals to amplify your tasks helps connect you with what you have to get done.

→ Sketchnotes are useful for a wide variety of plans: from task lists to travel to agile projects.

★ NEXT: SKETCHNOTE DOCUMENTATION

GENERATE

MAP

PLAN

DOCUMENT

Chapter 5

SKeTCHNoTe DOCUMENTATION

Sketchnoting is an effective way to convert information into concise visual documents that communicate processes and ideas.

SKETCHNOTE
documentation

Documentation of processes and ideas in sketchnote form make use of the built-in visual capacity we all possess. We are more likely to want to use documents with a blend of images and text because they're visually interesting and concise.

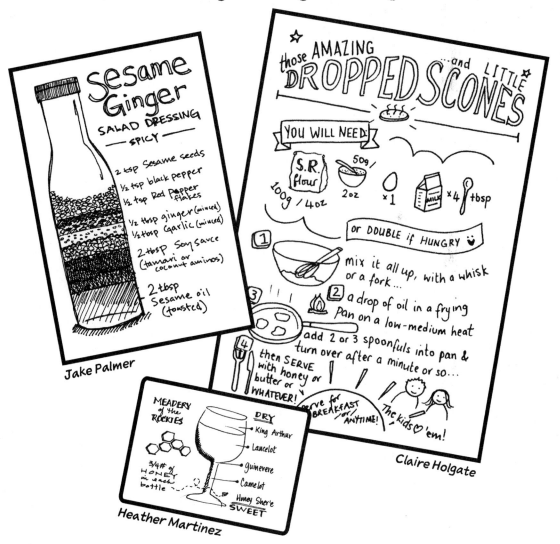

Jake Palmer

Claire Holgate

Heather Martinez

DOCUMENT step-by-step instructions, recipes, helpful tips, and diagnostic descriptions with sketchnotes rather than with pages of boring text.

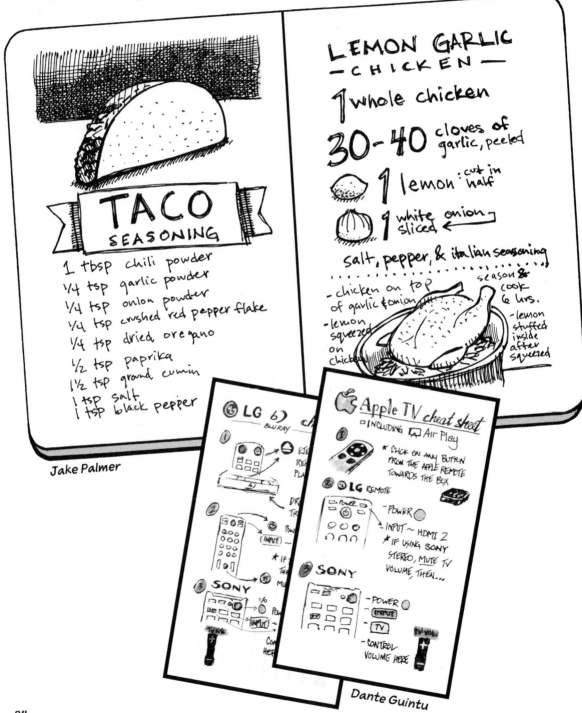

TACO SEASONING

1 tbsp chili powder
1/4 tsp garlic powder
1/4 tsp onion powder
1/4 tsp crushed red pepper flake
1/4 tsp dried oregano
1/2 tsp paprika
1 1/2 tsp ground cumin
1 tsp salt
1 tsp black pepper

Jake Palmer

LEMON GARLIC — CHICKEN —

1 whole chicken

30-40 cloves of garlic, peeled

1 lemon : cut in half

1 white onion sliced

salt, pepper, & italian seasoning

- chicken on top of garlic & onion
- lemon squeezed on chicken
- season & cook 6 hrs.
- lemon stuffed inside after squeezed

LG BLU-RAY
① EJE... RE... PLA...
DR... TR...
② POWER
INPUT ~
* IF ...
TH...
MU...
③ SONY
1/0
POW...
INPUT ~
TV VOL
Con... HERE

Apple TV cheat sheet INCLUDING Air Play
①
* CLICK ON ANY BUTTON FROM THE APPLE REMOTE TOWARDS THE BOX
② LG REMOTE
- POWER
- INPUT ~ HDMI 2
* IF USING SONY STEREO, MUTE TV VOLUME, THEN...
③ SONY
- POWER
- INPUT
- TV
- CONTROL VOLUME HERE
TV VOL

Dante Guintu

the BENEFITS OF SKETCHNOTE DOCUMENTATION

Documenting ideas, processes, and other information with sketchnotes provides several benefits:

THEY'RE COMPACT because objects, processes, and ideas are reduced to simple, rich drawings with notes.

THEY COMMUNICATE, as images blended with text reinforce each other, making them a more effective communication tool.

THEY DRAW READERS IN, since images and text together are more approachable than blocks of gray text.

THEY'RE SCANNABLE, as sketchnote documents communicate detailed information more quickly than detailed text descriptions alone.

THEY'RE FUN because drawings in a sketchnote can add humor, making the process amusing and lighthearted.

HOW TO CREATE A PROCESS DOCUMENT

The next few pages show my approach for process documentation. Adapt and improve this process to fit your own style.

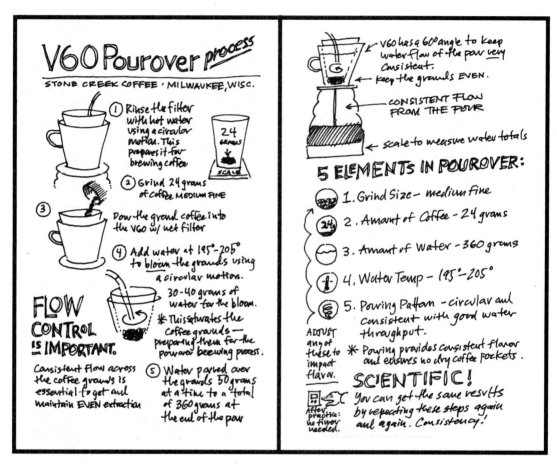

V60 Pourover *process*

STONE CREEK COFFEE · MILWAUKEE, WISC.

1. Rinse the filter with hot water using a circular motion. This prepares it for brewing coffee

2. Grind 24 grams of coffee MEDIUM FINE

24 GRAMS

SCALE

3. Pour the ground coffee into the V60 w/ wet filter

4. Add water at 195°-205° to bloom the grounds using a circular motion.

30-40 grams of water for the bloom.

✱ This saturates the coffee grounds — preparing them for the pourover brewing process.

FLOW CONTROL IS IMPORTANT.

Consistent flow across the coffee grounds is essential to get and maintain EVEN extraction

5. Water poured over the grounds 50 grams at a time to a total of 360 grams at the end of the pour

V60 has a 60° angle to keep water flow of the pour very consistent.

keep the grounds EVEN.

CONSISTENT FLOW FROM THE POUR

scale to measure water totals

5 ELEMENTS IN POUROVER:

1. Grind Size — medium fine
2. Amount of Coffee — 24 grams
3. Amount of Water — 360 grams
4. Water Temp — 195°-205°
5. Pouring Pattern — circular and consistent with good water throughput.

ADJUST any of these to impact flavor.

✱ Pouring provides consistent flavor and ensures no dry coffee pockets.

SCIENTIFIC!

After practice: no timer needed.

You can get the same results by repeating these steps again and again. Consistency!

★ OBSERVE AND CAPTURE ★

Documenting is as simple as observing steps and capturing them.

★ MESSY SKETCHNOTES ARE OKAY ★

If the first rough process document is too messy, creating a cleaned-up process document gives you a chance to further refine your thinking.

PROCESS DOCUMENT STEPS

Follow these five steps to create a sketchnote process document.

OBSERVE THE PROCESS

Observe a process several times, taking rough sketchnotes of what you see, and using images and text.

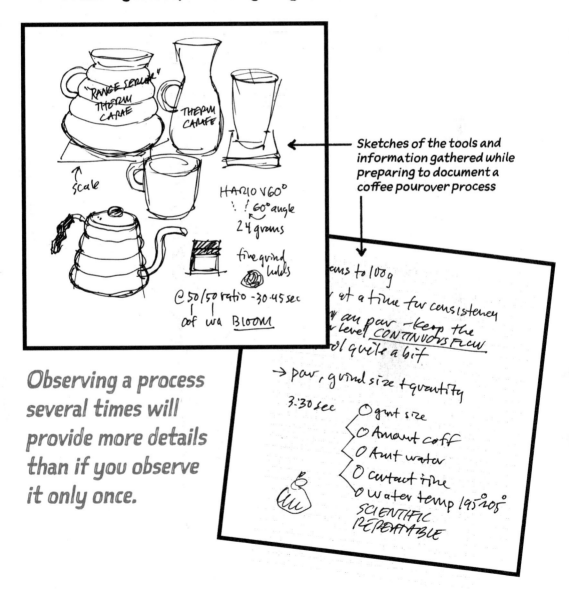

Sketches of the tools and information gathered while preparing to document a coffee pourover process

Observing a process several times will provide more details than if you observe it only once.

2 CAPTURE THE PROCESS

Describe what you see happening during the process and build an order of events, using numbering and hierarchy to show order and importance.

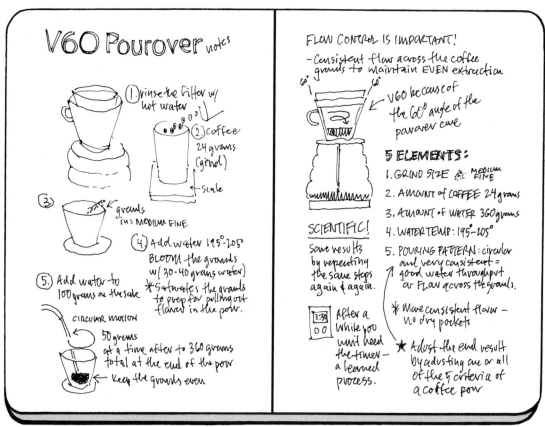

My first, rough sketchnote of a coffee pourover process

Don't worry about making your process document perfect the first time. Your focus should be on observing and asking questions that help you understand the process.

3 CREATE A SECOND SKETCHNOTE

Create a second version of the sketchnote, refining details, double-checking the flow and order of steps. You can use arrows to tie ideas together.

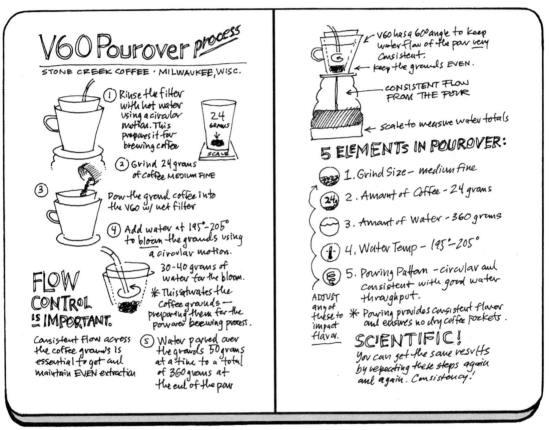

V60 Pourover *process*

STONE CREEK COFFEE · MILWAUKEE, WISC.

1. Rinse the filter with hot water using a circular motion. This prepares it for brewing coffee

24 GRAMS
SCALE

2. Grind 24 grams of coffee MEDIUM FINE

3. Pour the ground coffee into the V60 w/ wet filter

4. Add water at 195°-205° to bloom the grounds using a circular motion.
 30-40 grams of water for the bloom.
 * This saturates the coffee grounds — preparing them for the pourover brewing process.

FLOW CONTROL IS IMPORTANT.

Consistent flow across the coffee grounds is essential to get and maintain EVEN extraction

5. Water poured over the grounds 50 grams at a time to a total of 360 grams at the end of the pour

← V60 has a 60° angle to keep water flow of the pour very consistent.
← keep the grounds EVEN.
← CONSISTENT FLOW FROM THE POUR
← scale to measure water totals

5 ELEMENTS IN POUROVER:

1. Grind Size — medium fine
2. Amount of Coffee — 24 grams
3. Amount of Water — 360 grams
4. Water Temp — 195°-205°
5. Pouring Pattern — circular and consistent with good water throughput.

ADJUST any of these to impact flavor.

* Pouring provides consistent flavor and ensures no dry coffee pockets.

SCIENTIFIC!

You can get the same results by repeating these steps again and again. Consistency!

My second and final sketchnote of a coffee pourover process

Look for key ideas in the rough draft, and emphasize them in the final version of the sketchnote. This is a great time to illustrate those key ideas with drawings or type.

4 TEST YOUR DOCUMENT

Do an optional test-run of the second sketchnote to verify
the order and details of the document. Look for missed details.

Capture the process on video
so you can watch and observe
things you might have missed

5 DESCRIBE THE PROCESS

Add final observations on the second sketchnote,
incorporating improvements from the test run.

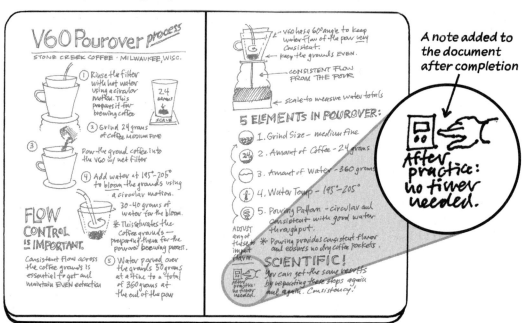

A note added to
the document
after completion

PRACTICAL USES

Here are a few ways to use sketchnotes for documentation:

★ STEP-BY-STEP PROCESSES

Sketchnotes using both drawings and annotated text are ideal for step-by-step processes. Drawings convey high-level detail in a compact space, with a bit of humor to make the process more fun.

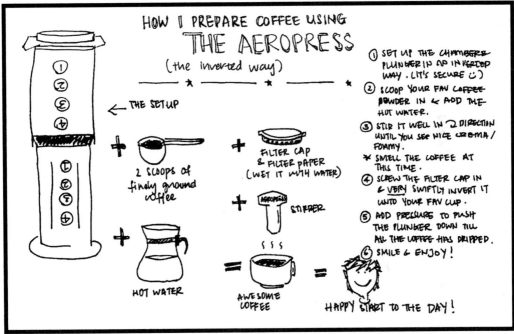

Winnie Lim's AeroPress sketchnote features the tools and ingredients on the left, and a numbered step-by-step description of preparation on the right.

WINNIE LIM'S sketchnote shows how she inverts her AeroPress coffee maker so the grounds brew longer for stronger coffee.

TIP **NUMBER THE STEPS IN YOUR PROCESS**

Make it easy on yourself or others who follow your directions later on by using numbers or letters to indicate steps in the process. You can also amplify numbers and letters with arrows to suggest a certain flow, or even show decision points within a process.

 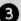

RECIPES are another way to capture step-by-step instructions combined with specific actions and ingredients. Jeff Bennett uses sketchnotes to share recipes with his friends. For example, this Beer Braised Short Ribs recipe is simple, visual, and effective.

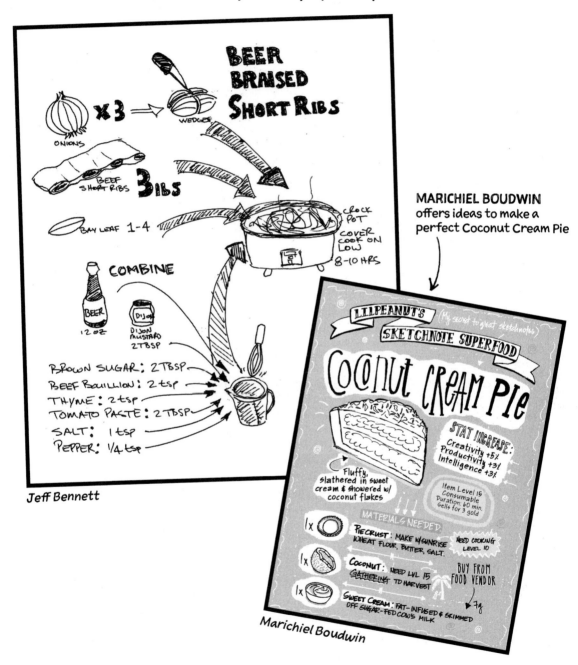

MARICHIEL BOUDWIN offers ideas to make a perfect Coconut Cream Pie

Jeff Bennett

Marichiel Boudwin

C CREATE A SKETCHNOTE RECIPE

Create a sketchnote of your favorite recipe using a rough sketch first and then refining the final version, like the sample below by Mauro Toselli. Share this recipe with a friend or family member.

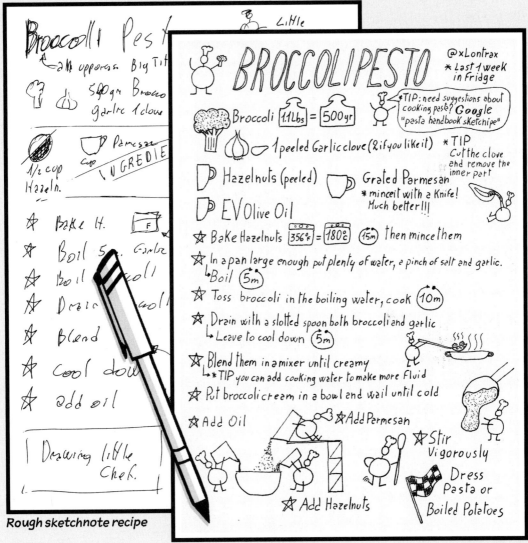

Rough sketchnote recipe

Final sketchnote recipe

QUESTIONS

How did creating a visual recipe change your view of the information?
How did the recipient react to the sketchnote recipe?

★HOW-TO DOCUMENTS

Process documents require a step-by-step approach because the order in which you complete the steps is important. But when you're teaching concepts, such as in these explanatory sketchnotes, the order of events is not always vital, freeing you to use images instead of numbers to get your point across.

JONO HEY keeps his how-to sketchnotes, or *sketchplanations*, even simpler with just one or two ideas on a single card.

Jono Hey • sketchplanations.com

TIP **FOCUS ON KEY PRINCIPLES RATHER THAN STEPS**

Think of your how-to document as a way to share key concepts or your secrets, rather than confining yourself with steps.

MAURO TOSELLI has created a library of sketchnoted how-to documents, like his Pasta Handbook. His one-page sketchnote breaks pasta cooking principles into Do's and Don'ts, with whimsical drawings to illustrate each concept.

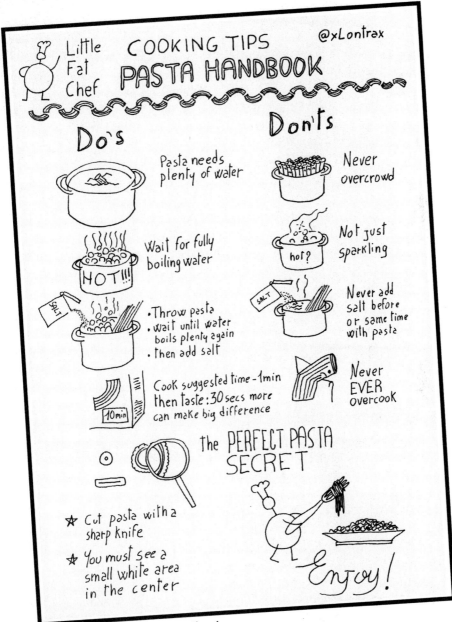

Mauro Toselli's Pasta Handbook

★COMMUNICATING IDEAS

You can use sketchnotes to document principles by creating them live with another individual or group of people. Interactive sketchnotes for communication draw collaborators into the discussion and allow them to offer feedback.

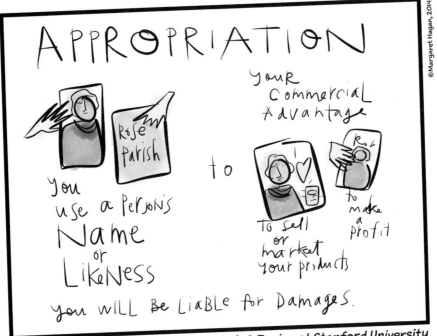

Margaret Hagan, Program for Legal Tech & Design at Stanford University

I'VE FOUND THAT SKETCHNOTES CREATED IN A COLLABORATIVE WAY TEND HAVE HIGHER BUY-IN BECAUSE EVERYONE IS PART OF THE SOLUTION.

TIP **USE A WHITEBOARD FOR COLLABORATION**

Whiteboards provide a semi-permanent space for capturing sketchnotes that you can easily adjust with feedback. By working with a whiteboard, you can also invite those involved in the process to contribute to the sketchnote. Take a photo before you erase the board for later reference.

PEDIATRICIAN BRYAN VARTABEDIAN creates clinical sketchnotes at the Texas Children's Health Center in The Woodlands, Texas. He uses his whiteboard to visually document his patient's symptoms, the diagnosis, and possible treatment plans. This all happens live while the child and the parents are in the exam room.

Dr. Vartabedian says both the child and parents appreciate a simple boil-down of the child's problems, with the ability to correct or modify facts on the spot.

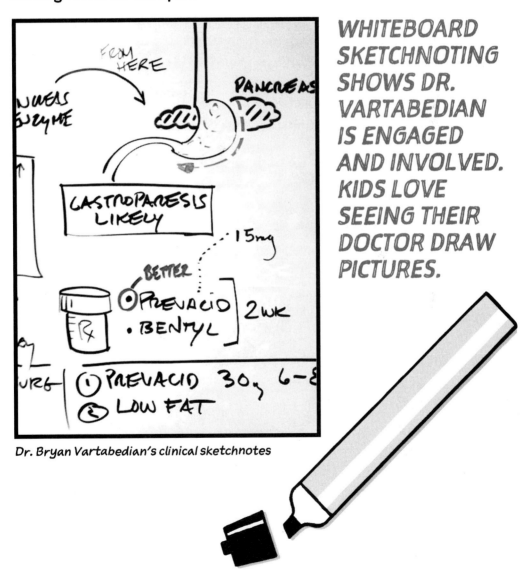

Dr. Bryan Vartabedian's clinical sketchnotes

WHITEBOARD SKETCHNOTING SHOWS DR. VARTABEDIAN IS ENGAGED AND INVOLVED. KIDS LOVE SEEING THEIR DOCTOR DRAW PICTURES.

Mauro Toselli

USING SKETCHNOTES TO SHARE FAVORITE DISHES

Mauro is an IT director working for a publishing company in Italy. He loves to cook, which led him to start documenting his favorite recipes and cooking how-to's with sketchnotes.

A year ago a friend asked Mauro for a recipe. Because he had read *The Sketchnote Handbook*, he wanted to do something other than a boring list of ingredients and procedures. He had an idea: Why not try sketchnoting the recipe?

Mauro had a blast creating the sketchnote recipe and his friend loved receiving and using it to cook from.

Now Mauro is hooked. He continues sketchnoting recipes because creating them visually provides new ideas for improving the meal, and the sketchnoting process involves all of his senses.

Plus, he can share them with friends, family, and even the world.

"Don't be afraid to show your sketchnotes. Keep everything you draw. Review old sketchnotes from time to time to understand how you've improved and to see what you can do to get better."

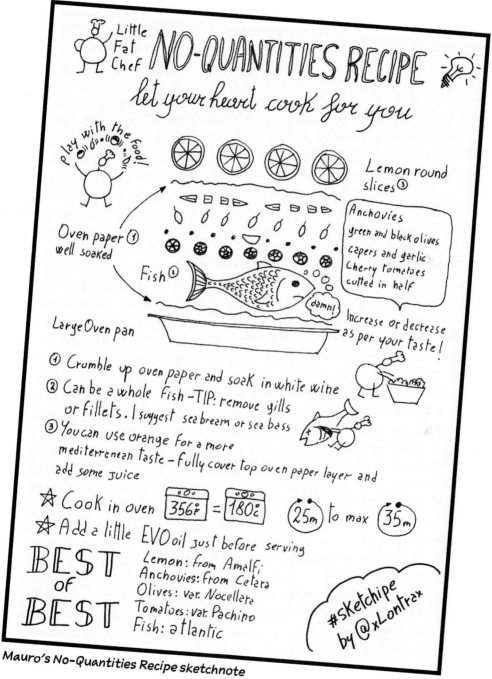

Little Fat Chef NO-QUANTITIES RECIPE

let your heart cook for you

Play with the food!

Lemon round slices ③

Oven paper ① well soaked

Anchovies
green and black olives
capers and garlic
Cherry tomatoes
cutted in half

Fish ②

damn!

Increase or decrease as per your taste!

Large Oven pan

① Crumble up oven paper and soak in white wine
② Can be a whole fish -TIP: remove gills or fillets. I suggest sea bream or sea bass
③ You can use orange for a more mediterrenean taste - fully cover top oven paper layer and add some juice

☆ Cook in oven `356°F` = `180°C` (25m) to max (35m)
☆ Add a little EVO oil just before serving

BEST of BEST

Lemon: from Amalfi
Anchovies: from Cetara
Olives: var. Nocellara
Tomatoes: var. Pachino
Fish: atlantic

#sketchipe by @xLontrax

Mauro's No-Quantities Recipe sketchnote

ICONS FOR DOCUMENTATION

In the grid below, use squares, circles, triangles, lines, and dots to create icons for each word related to documentation. Skip ahead if you get stuck. The last row is blank so you can create your own icons.

BAKE	SAUTÉ	DO	DON'T
425°			
MINUTES	HOURS	MARINATE	CHOP
STIR	BLEND	WHISK	BOIL
TSP	TBSP	CUP	DASH

RECAP

→ You can use sketchnotes to document step-by-step instructions, recipes, and diagnostic descriptions.

→ Sketchnote documents make use of the built-in visual capacity we all possess.

→ Objects, processes, and ideas are reduced to simple, rich drawings with notes.

→ Images blended with text reinforce each other.

→ Visual documents draw readers in.

→ Sketchnotes communicate detailed information more quickly than detailed text descriptions alone.

→ Collaborative sketchnoting creates better buy-in because everyone is part of the solution.

★ NEXT: SKETCHNOTING TRAVEL

TRAVEL FOOD MEDIA

Chapter 6

SKETCHNOTING TRAVEL *experiences*

Sketchnotes are a fun way to capture
and document memorable travel experiences
with drawings, type, text, and other elements.

SKETCHNOTING
Travel
EXPERIENCES

The visual travel stories you create can become artifacts that capture a moment in time. These sketchnotes are useful for personal reflection and can become priceless keepsakes shared with your children and grandchildren.

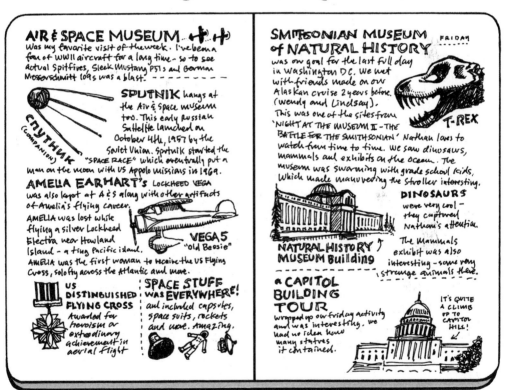

My Washington, D.C. travel sketchnotes from April 2011

When memories fade, travel sketchnotes act as time capsules for your experiences.

YOU CAN CREATE TRAVEL SKETCHNOTES IN THE MOMENT OR UPDATE THEM AT THE END OF THE DAY, BASED ON NOTES AND PHOTOS CAPTURED ALONG THE WAY.

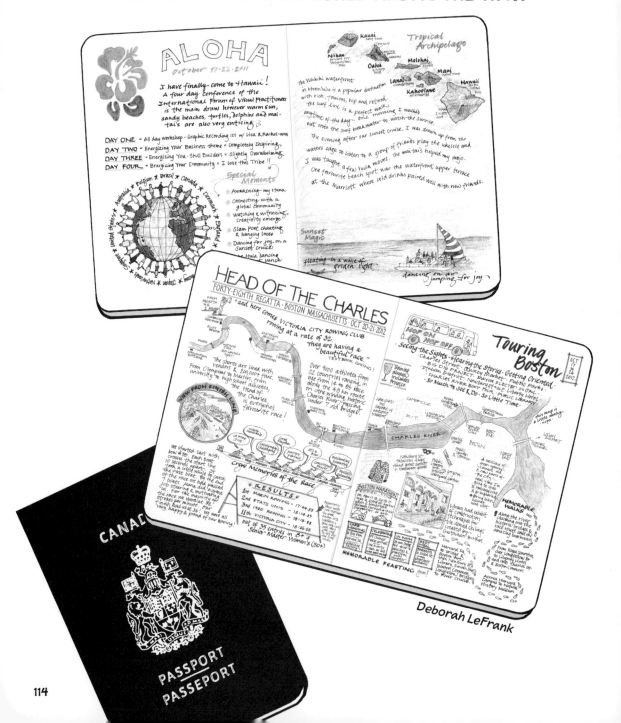

Deborah LeFrank

the BENEFITS OF TRAVEL SKETCHNOTES

Travel sketchnotes have several attractive benefits:

 KEEP TRACK of what happens as you travel. If you don't document your activities, they'll blend together, or worse yet, you'll lose them forever.

 SKETCHNOTES CREATE A MENTAL MAP of your experiences that can bring back highly detailed memories even years later.

 EXPLORATION IS ENCOURAGED when you keep a sketchnote travel journal. You seek out interesting experiences and record them in more detail.

 SHARING IS EASY with sketchnotes. Your friends and family can enjoy your travel stories via email, social media, as printouts, or even in photo books.

 YOU'RE MAKING A KEEPSAKE by capturing memories of historical places and artifacts, documented in a unique, personal way.

BUY A GOOD QUALITY SKETCHBOOK AND PEN

You can capture sketchnotes with any paper and pen. However, by choosing a beautiful sketchbook and a pen you love to use, you're making a commitment to capture your travels in style and can turn sketchnoting your travels into a treasured luxury gift to yourself.

One of my favorite items is a handmade leather sketchbook I've used to sketchnote trips to Washington, D.C. and Portland. I love how it feels to fill the pages. My Retro 51 Tornado Stealth rollerball pen is a joy to write and draw with. My green travel book is *already* a treasured family heirloom.

WE SOUGHT OUT PORTLAND PIZZA PLACES

and settled on a visit to OLD TOWN PIZZA in Chinatown near the river. The old building was reputed as haunted, though we never saw any apparitions. WE DID have some delicious pizza and breadstick twists however. OLD TOWN's crust made the difference - though the sausage and pepperoni were damn tasty too.

OLD TOWN PIZZA

OLD TOWN PIZZA PIE w/ original dough and tasty fresh pepperoni and sausage. Can't go wrong here partner.

THE VANPORT DELIVERY BIKES

are especially interesting— with a storage box on the front of the bike that requires linkage to turn the bike's front wheel.

Pizza box

PORTLAND OBSERVATIONS

I wanted to capture some observations of Portland, now that we've returned home to Milwaukee.

- -

★ **EASY TO GET AROUND** - we rode into the city on a light rail train, walked everywhere 90% of our stay and even caught a bus over to Voodoo Doughnut. Everything we as visitors was easy to get to - and reasonably priced. WASHINGTON DC, ATLANTA and PORTLAND all share this and I miss it here in Milwaukee.

CULTURE is celebrated well in Portland— I think even the smallest coffee shop had its own gallery — and the food trucks offered a wide range of cultural food options.

BOOKS - It's hard not to mention Powell's Books when you talk about Portland. We spent several hours exploring the city of books store downtown and could have spent hours more with their selection.

BREW - Coffee was of course a highlight of our visit and the beer brewing community in Portland is alive and well too. It's great to see such dedication given to these areas.

OVERALL Portland felt comfortable and like Milwaukee, yet different in all of the right ways. I can't wait to visit Portland again.
— MIKE

Ugmonk green leather travel sketchbook

Retro 51 Tornado Stealth rollerball pen

PRACTICAL USES

Here are some ways to use sketchnotes to capture travel experiences:

★PERSONAL TRAVEL SKETCHNOTES

For personal travel, sketchnote the places, sights, food, highlights, and stories you want to remember from a personal or family vacation. Share your final sketchnotes or use them to create a bound picture book combined with trip photos.

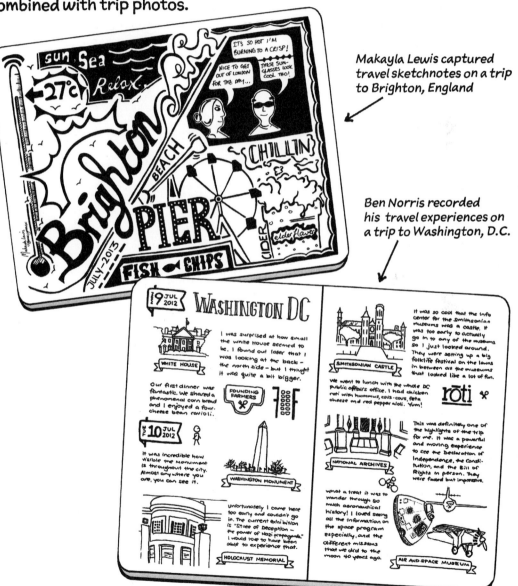

Makayla Lewis captured travel sketchnotes on a trip to Brighton, England

Ben Norris recorded his travel experiences on a trip to Washington, D.C.

PASTE ITEMS IN YOUR SKETCHBOOK

Ticket stubs and other flat items can be a great way to remember a moment. Carry glue or tape along to stick these items right into your journal pages. Surround the glued items with notes or drawings about the experiences.

With a little bit of daily effort capturing travel experiences as sketchnotes, you'll build a rich collection of stories and moments that will endure long after the trip is over.

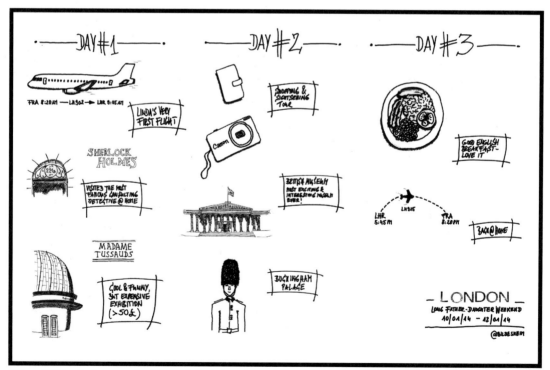

Oliver Bildesheim created travel sketchnotes while visiting London

CHALLENGE 6.1

© SKETCHNOTE A PERSONAL TRIP

Use a pocket notebook or note app to capture a running list of the day's activities. Shoot photos with your camera, and if possible, take time to sketchnote some experiences in the moment. At the end of the day, convert your research into travel sketchnotes.

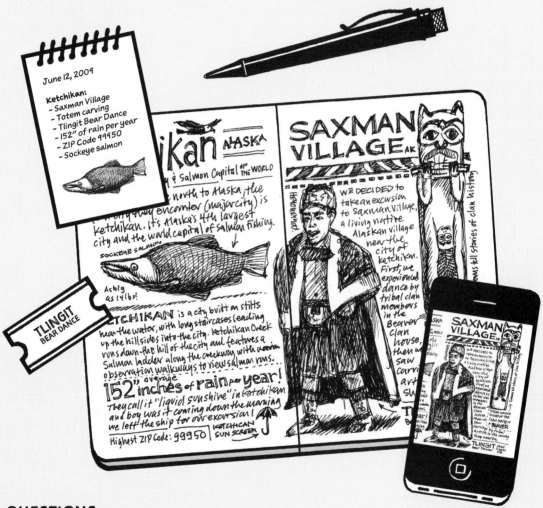

QUESTIONS

Share the sketchnote with a fellow traveler or a friend. What's their impression of your trip sketchnote? How did capturing travel change your perspective of the trip? Look again in one month: Does the sketchnote bring back details more clearly?

119

★BUSINESS TRAVEL SKETCHNOTES

Sketchnotes can be valuable on business trips. Visually document your thinking about a conference, meeting, or task. Record lunch and dinner meetings, note your expenses, and reflect on your experience as you head back home.

World DOMINATION SUMMIT 2013 — with ★ CHRIS GUILLEBEAU ★★★★

PORTLAND _Oregon_

THIS is not my first time in Portland, but it is my first World Domination Summit. Portland is an excellent location — so much to do in this interesting city.

@vinodesign

TRI-MET Light Rail Airport → Downtown

LUNCH at the ORIGINAL with friends Mike Vardy and Michael Schechter (Mikes on mics) included POUTINE — awesome!

→ FRY
→ CHEESE CURD — melted
→ BEEF GRAVY

GRILLED CHEESE Sandwich + **POUTINE** FRENCH FRIES, CHEESE CURDS and GRAVY

The first time I've had poutine was not in Canada — but was it good!

CHECKED-IN for WDS at Director Park with hundreds of other attendees — swag included a bag, t-shirt, tickets and of course — socks!

Some of the most memorable moments at Chris Guillebeau's World Domination Summit in 2013 were before, after, and in-between sessions

I spent a two-hour flight home from SXSW Interactive sketchnoting my observations and takeaways from the festival

TAKEAWAYS from SXSW Interactive

SXSW IS MADE FOR ME — NOT I FOR IT.

I sketchnoted more food than panels this year. I met more people this year. Even though panels were limited it was still great to connect with others. I've learned to make SXSW into what I need it to be — that's my responsibility — not anyone else's.

YOU MUST FIRST GIVE, THEN YOU CAN TRULY RECEIVE. GIVE Freely

STOP STANDING THERE and SAY HELLO to PEOPLE YOU ADMIRE!

Most "famous" people at SXSW Interactive are really friendly and nice. If you encounter a jerk, move on to someone else who is nice + friendly.

"FAMOUS" at SXSWi EQUALS PRETTY MUCH NOBODY STATUS IN A WORLD of 6 BILLION PEOPLE.

TAKE PHOTOS OF YOUR TRAVEL SKETCHNOTES

Take photos with your smartphone or other camera each day. This allows you to back up your work and makes it easy to share your experiences with friends in social media or with colleagues at work.

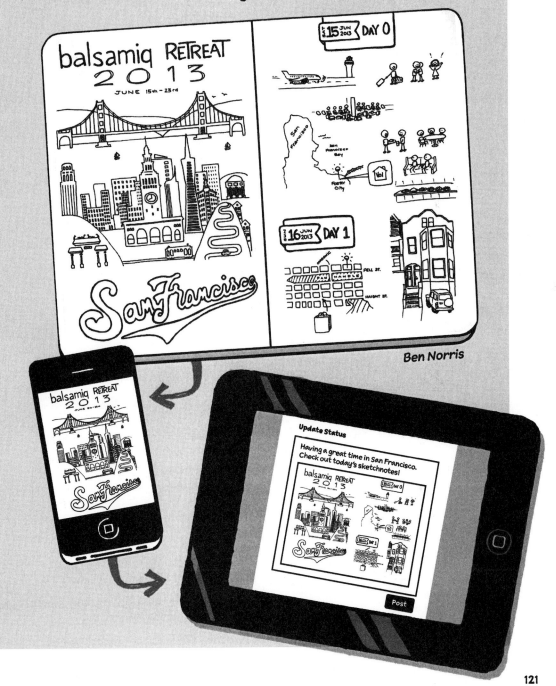

Ben Norris

CHALLENGE 6.2

SKETCHNOTE A BUSINESS TRIP

Create a travel sketchnote on your next business trip. Document the things you're thinking about as you prepare for your meeting, conference, business activity, and people you'll meet. Note details from meetings, capture your expenses, and use time on the trip home to reflect on your experiences.

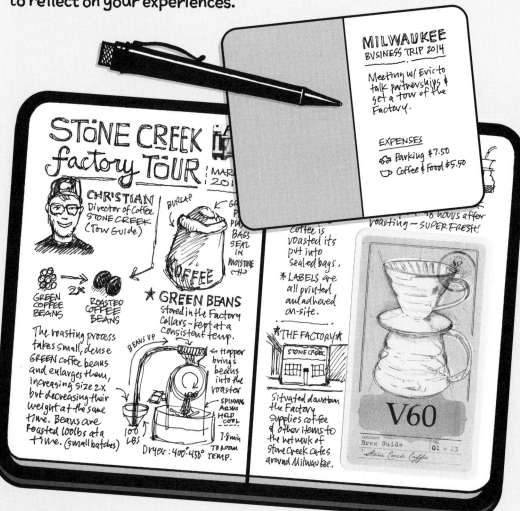

QUESTIONS

Did your awareness of travel details and business events improve through sketchnoting? Did the sketchnoted document help reveal what you've learned and observed more clearly?

TRAVEL SKETCHNOTE STEPS

Follow these three steps to create your own travel sketchnote.

 ## SEEK WHAT'S INTERESTING

What should you sketchnote? Here are some ideas:

→ **FOCUS ON THE CITY ITSELF.** Are there buildings defining the skyline? A mountain in the distance? A river or other landmark that will spark your memory?

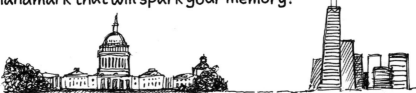

→ **SEEK OUT THINGS THAT ARE DIFFERENT.** In Portland I found strange, four-spout drinking fountains on downtown streets, so I drew one as part of the sketchnote in my book.

→ **TALK TO PEOPLE AND RECORD THEIR STORIES.** Ask them to share a bit of history about the city, or share a favorite local restaurant or activity to try.

→ **DOCUMENT MEMORABLE STORIES.** Note favorite cafés or streets and capture funny stories, like the American marching band I saw playing *Copa Cabana* through the old section of Stockholm, Sweden.

MEMORABLE, STRANGE, AND FUN EVENTS HELP JOG YOUR MEMORY.

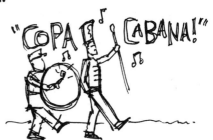

2 TAKE NOTES AND SHOOT PHOTOS

You may not have time to sketchnote your experiences in the moment while on a busy travel schedule. Here are ways to capture experiences and create a reference:

→ **CARRY A SMALL NOTEPAD,** or use a note app to jot down things you do during a day's travels. Record places, times, and stories as they happen. At the end of the day, use your notes to build sketchnotes in your sketchbook.

June 12, 2009

Ketchikan:
- Saxman Village
- Totem carving
- Tlingit Bear Dance
- 152" of rain per year
- ZIP Code 99950
- Sockeye salmon

→ **USE A CAMERA** to take photos of locations, people, and artifacts. Reference images to accurately create drawings in your sketchnotes later on.

THE BEST CAMERA IS THE ONE YOU HAVE WITH YOU.

 # MAKE TIME TO SKETCHNOTE

Sometimes you can sketchnote as you're traveling; other times you may have to wait for the end of the day. Here are tips for making time for sketchnotes as you travel:

→ **LOOK FOR DOWNTIME.** Use breaks to sketchnote in the moment. Lunch, coffee, or even rest times can offer a few moments to sketchnote an experience from your day.

→ **PLAN LONGER LUNCHES,** making more time for sketchnoting. Building in extra time will give you a chance to reflect and create sketchnotes.

→ **DEVOTE TIME AT THE END OF THE DAY** to reflect on your experiences and create sketchnotes. I have kids, so the best time for me to work is at the end of the day.

SKETCHNOTING TIME IS HARD TO FIND ON THE ROAD. IF YOU CARVE IT OUT OF YOUR DAY, YOU'LL BE REWARDED WITH VIVID MEMORIES.

TIP **LEAVE SPACE FOR LATER**

If you have a chance to draw a landscape or artifact in the moment but want space to sketchnote earlier activities, here's how to do it. Estimate the space you'll need to complete that day's sketchnote. Create the drawing in a spot on the page that allows room for more drawings and writing. When you create your final sketchnote at the end of the day, work around the drawing already in place.

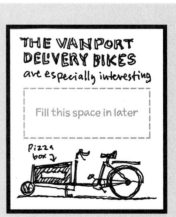

THE VANPORT DELIVERY BIKES are especially interesting

Fill this space in later

pizza box

HERE'S AN EXAMPLE OF ROUGH AND FINAL TRAVEL SKETCHNOTES FROM A TOUR OF STONE CREEK COFFEE'S FACTORY:

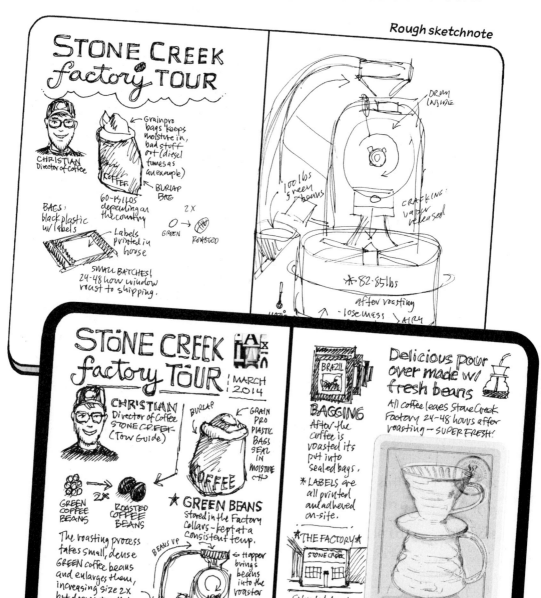

Rough sketchnote

Final sketchnote

MORE TRAVEL SKETCHNOTES:

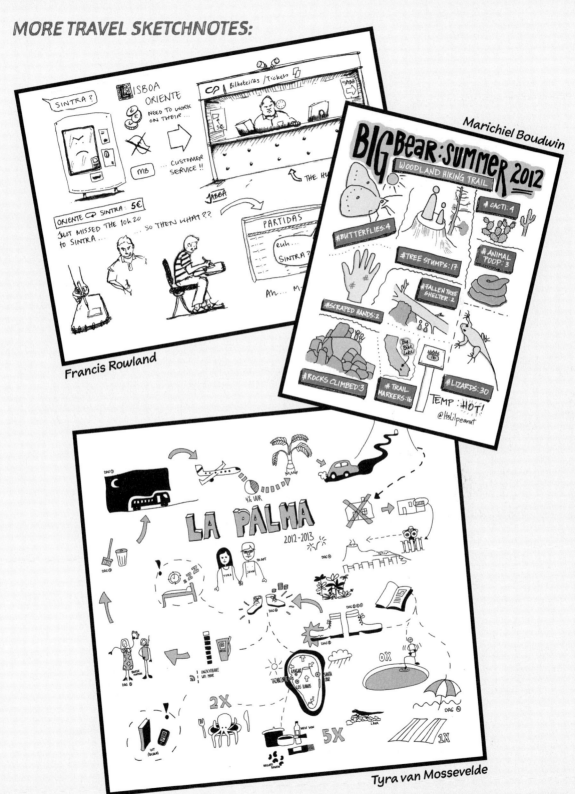

Francis Rowland

Marichiel Boudwin

Tyra van Mossevelde

Chris Spalton

SKETCHNOTES TURN TRAVELS INTO VISUAL MEMENTOS

Chris is a designer from England who uses sketchnotes to capture meetings as well as for design activities at work. Recently, he's broadened his sketchnoting to include travel experiences.

Chris has found travel sketchnotes are a more personal way to record a trip compared to simply taking photos. Rather than queue up at tourist hotspots to take exactly the same photo as everyone else, he seeks to capture unique experiences in his sketchnotes.

Combining words with drawings allows Chris to capture his experience, recording how he actually felt in a particular place. He seeks the funny, unusual things that stand out as a way to kick-start his memory later on.

Injecting his personality into sketchnotes makes them become unique and memorable, and more compelling when he shares them online.

His process features taking lots of photos and keeping notes of things that stand out during the day. Then he finds refuge in a café, hotel room, or on the train home to turn his notes and photographs into travel sketchnotes.

"It's great fun to draw things that end up as a memento of your visit that is worth more than a thousand pictures."

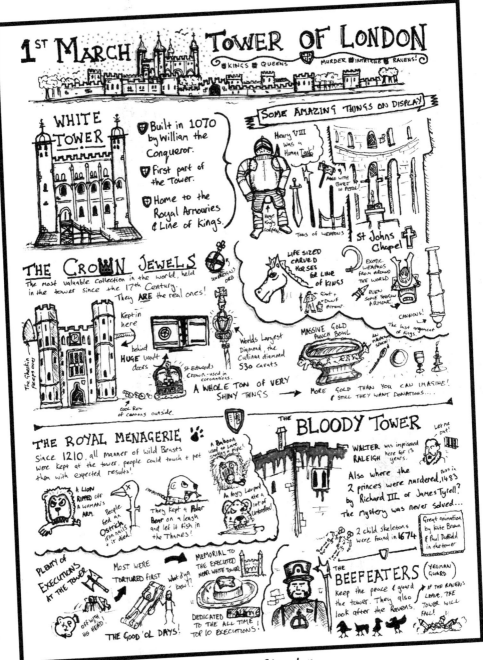

Chris' travel sketchnote from the Tower of London

W ICONS FOR TRAVEL

In the grid below, use squares, circles, triangles, lines, and dots to create icons for each word related to travel. Skip ahead if you get stuck. The last row is blank so you can create your own icons.

TRAIN	FLIGHT	INCOGNITO	CURRENCY
HOSTEL	PASSPORT	BREAKFAST	ROAD KILL
DINER	CAFÉ	STROLL	OCEAN
BOARDWALK	BEACH	SIESTA	CRUISE SHIP

RECAP

→ Travel sketchnotes are a fun, personal way to document experiences that you can enjoy later, or share with friends and family.

→ Visual travel stories become treasured artifacts that capture a moment in time.

→ Travel sketchnotes help you keep track of your trips. If you don't document activities, they'll blend together, or you'll lose them forever.

→ Travel sketchnotes can bring back highly detailed memories even years later.

→ Sketchnotes captured on personal and business travel are valuable both for the memories they capture and as tools for reflection.

→ Devote time at the end of the day to reflect and create your sketchnotes.

→ Take photos of your sketchnotes to back up your work and then share it with family and friends.

★ NEXT: SKETCHNOTING FOOD

TRAVEL

FOOD

MEDIA

Chapter 7

SKETCHNOTING
FOOD experiences

Capture delicious meals with sketchnotes
using drawings, type, and text.
Create visual records of your fantastic
food experiences to enjoy and share.

SKETCHNOTING *food* EXPERIENCES

How would you like to capture a fabulous meal experience
in vivid detail? Sketchnoting is a rich, visual way
to capture eating experiences like breakfast
in another city, lunch at an outdoor café,
an anniversary dinner, or a coffee tasting.

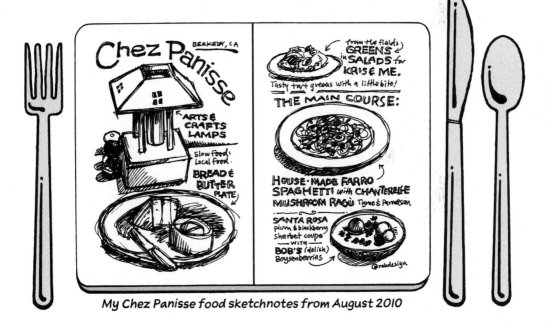

My Chez Panisse food sketchnotes from August 2010

*Sketchnoting food helps you savor experiences
and remember them more clearly later on.*

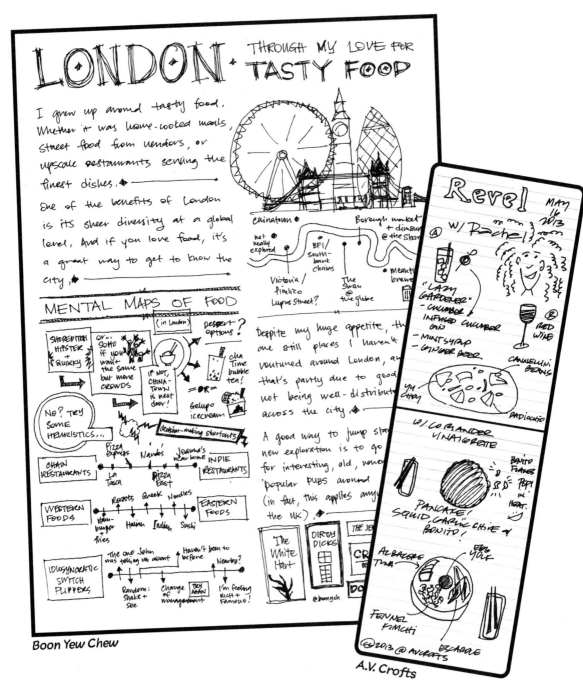

Boon Yew Chew

A.V. Crofts

the BENEFITS OF FOOD
SKETCHNOTES

Food sketchnotes have several attractive benefits:

 CREATE ANCHORS in your memory by recording your food and drink, location, environment, thoughts, and feelings in the moment.

 GAIN KNOWLEDGE as you visually record new information about food origins, preparation methods, or unique flavors.

 SHARE FOOD SKETCHNOTES with your friends and family via email and social media.

 SAVOR YOUR FOOD as you slow down to sketchnote what you've eaten. Your meal experience becomes more deliberate.

 HAVE A COLLECTION of food preparation ideas once you've built your food sketchnotes.

CREATING A FOOD SKETCHNOTE

Sketchnoting food is one of my favorite ways to capture an experience. Here's how I create food sketchnotes:

1 PREPARE YOUR TOOLS

Carry a sketchbook and pen. Bring a smartphone or camera so you can take photos of your meal for reference.

2 ASK QUESTIONS

LOCAL?

Are there any special or unusual ingredients in the dish? Are ingredients locally sourced? Can you tell me about the chef and their ideas on food? Note these details for reference.

3 TAKE PHOTOS OF THE MEAL

Take photos of the meal once it arrives, and if you like, get shots of specific details. This creates a useful visual reference and allows you to eat before sketchnoting.

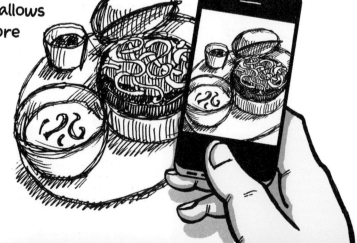

4 ENJOY YOUR MEAL

Take time to ponder the tastes, textures, smells, and your senses. Note these details in your notebook if you like. You can refer to your tasting notes when you sketchnote the meal.

5 OBSERVE YOUR SURROUNDINGS

Be aware of the environment and the people you're eating with, especially if the meal is a special occasion.

6 START SKETCHNOTING

When the meal is done, clear away your dishes and start sketchnoting, using photos, notes, and memory as reference.

7 ADD PERSONAL COMMENTS

Add your thoughts about flavors, what you liked best, or what you didn't care for. This will add a unique reference that improves recall.

cilantro YEAH! ★★★★★ Delicious flavor—love the asian strings + guac. delicious! HOUSE MADE SALSA

8 TAKE PHOTOS OF THE SKETCHNOTE

Create a backup of your work and have the option to share the image online with friends and family.

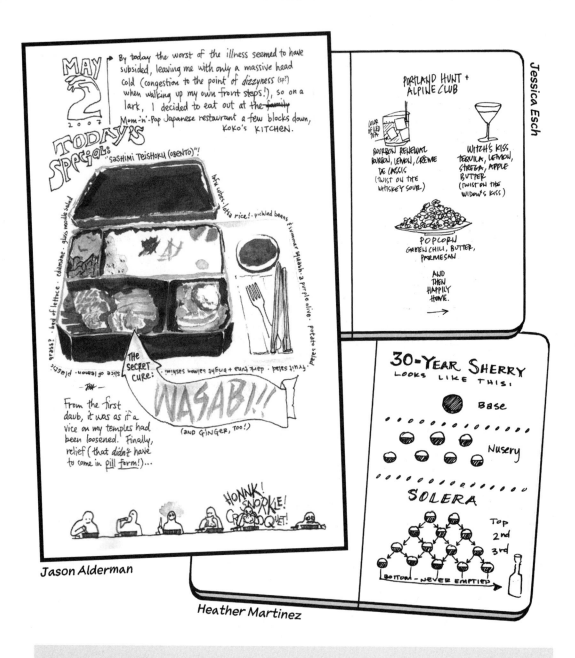

Jason Alderman

Heather Martinez

Jessica Esch

SKETCHNOTE MEALS AS A GROUP

Make a game of food sketchnotes by taking a group of friends or your family out to eat together. Each person can choose a different meal, take photos and notes, and then sketchnote their meal. Share your sketchnotes with each other, using your drawings and notes to describe your meal.

CHALLENGE 7.1
C SKETCHNOTE A MEAL AT A RESTAURANT

Choose something unusual or different. Take photos for reference; enjoy the food, taking notes as you eat. At the end of the meal, sum up your thoughts, using photos and your notes to sketchnote the meal. Add comments around the drawing of the tastes, environment, people, and your overall experience.

QUESTIONS
How did knowing you would sketchnote your meal change your appreciation of the details? Did it amplify them? Did you slow down more than usual? How much detail can you remember from your food sketchnote a week later? A month later?

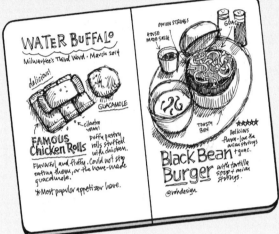

CHALLENGE 7.2
C SKETCHNOTE A TASTING EXPERIENCE

Taste different variations of a favorite food or drink and then sketchnote your observations. Ideas for food: a selection of cheeses, Chinese dim sum, or Spanish tapas. For drinks: a variety of coffees, teas, wines, or beers. Eat or drink each sample, take photos and notes, and then create a series of individual or grouped sketchnotes to document the experience.

QUESTIONS
Did sketchnoting a series of foods or drinks provide different insights about them? Were you able to pinpoint a favorite food or drink through the tasting process?

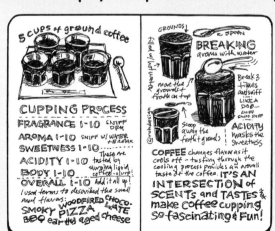

Sam "Pub" Smith
THE JOY OF FOOD CAPTURED WITH VISUAL FLAIR

Sam "Pub" Smith is an interaction designer from England, splitting his time between urban London and Stroud, a small town in the Cotswolds. He enjoys eating and loves to sketchnote memorable food experiences.

Sam prefers capturing personal insights and comments about the overall experience in his hand-drawn sketchnotes. Sam uses his encyclopedic collection of food sketchnotes for his own reference and to share as restaurant recommendations.

His sketchnotes start with the restaurant's logo, which he gets from menus, plates, napkins, or signage. He'll add the date and city, and take photos of the decor, the view, the people he's with, and, when it arrives, the food itself.

Sometimes Sam captures the people he is with or something funny said at the table and makes it the center point of the sketchnote. Food isn't always the star for him.

If he's caught without his sketchbook, he'll doodle on napkins, turning those doodles into a proper sketchnote when he gets home.

"I'll pick out a few things from a meal that are memorable or special. Adding my thoughts and observations to a food-related sketchnote preserves a memory I can enjoy later."

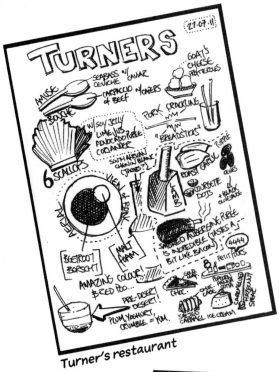

Turner's restaurant

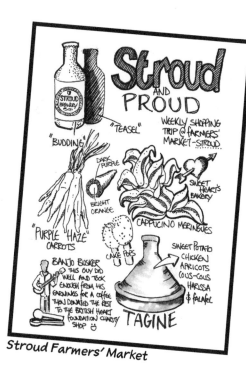

Stroud Farmers' Market

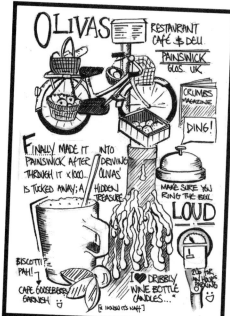

Olivas' restaurant, café, and deli

W ICONS FOR FOOD

In the grid below, use squares, circles, triangles, lines, and dots to create icons for each word related to food and eating. Skip ahead if you get stuck. The last row is blank so you can create your own icons.

APPETIZER	DRINK	SALAD	BREAD
WINE	SUSHI	STEAK	LOBSTER
SODA	PIZZA	TACO	CHEESESTEAK
BURGER	NOODLES	MEATBALLS	PHO

R E C A P

→ Sketchnoting food helps you savor experiences and remember them more clearly later on.

→ Documenting a meal helps you understand and visually record new knowledge about food origins, preparation methods, or unique flavors.

→ Your meal experience becomes more deliberate when you sketchnote it.

→ Ask questions about the chef, special ingredients, and locally sourced elements, and then capture those details in your sketchnote.

→ Add personal comments about the flavors, such as what you liked best or didn't care for. This adds a unique reference that improves recall.

→ Food sketchnotes are fun and easy to share with friends and family.

★ NEXT: SKETCHNOTING MOVIES, TV, & MEDIA

TRAVEL

FOOD

MEDIA

Chapter 8

SKETCHNOTING
MOVIES, TV, & MEDIA

Sketchnotes are a useful way to process,
understand, and capture the meaning in movies,
TV shows, and other kinds of media.

SKETCHNOTING
MOVIES, TV, & *Media*

We swim in an ocean of audiovisual media: A constant ebb and flow of messages washes over us daily. Sketchnotes are a unique way to draw meaning from the movies, TV shows, and other kinds of media we experience.

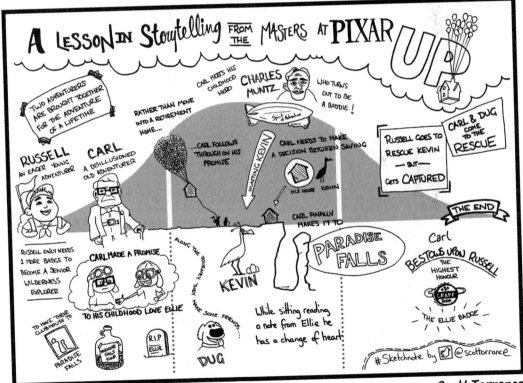

Scott Torrance

Discover the storylines embedded in movies by sketchnoting as you watch.

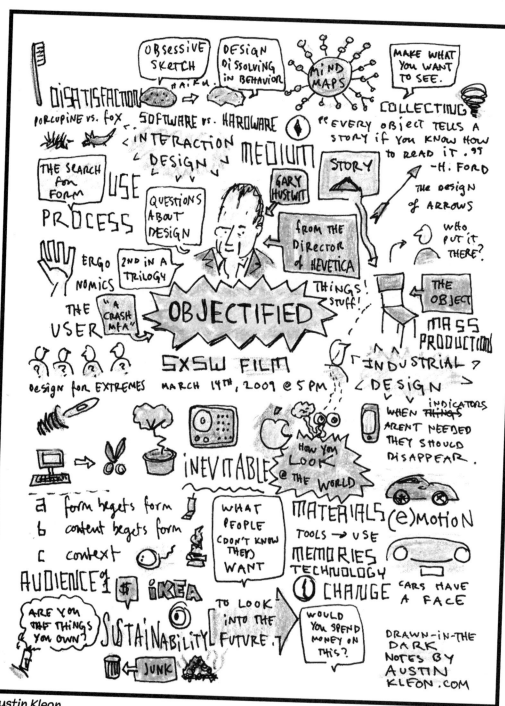

Austin Kleon

the BENEFITS OF SKETCHNOTING
MOVIES, TV, & MEDIA

Sketchnoting media experiences can include movies, TV shows, books, sporting events, and music, and have many benefits:

 UNDERSTAND what writers, directors, and actors are communicating through that media by creating a visual map of movies, TV shows, and other media.

 ENGAGE WITH THE STORY characters, conflict, and resolution as you watch, listen, or read.

 BUILD A SKETCHNOTE MAP of characters, references, or anything else that piques your curiosity from movies or TV shows.

 CAPTURE NEW KNOWLEDGE and thoughts within documents for reference or sharing.

 CREATE A LIBRARY of sketchnotes that store ideas, lessons, and inspiration from media sources.

CREATING A SKETCHNOTE FROM A MOVIE, TV SHOW, OR VIDEO

Here are the steps for creating sketchnotes from video sources:

 ## PREPARE YOUR ENVIRONMENT

Prepare your environment. Choose a sketchbook and a pen, find a comfortable location, and queue up the video. You can use a flat surface, like a table or TV tray, to make sketchnoting easier.

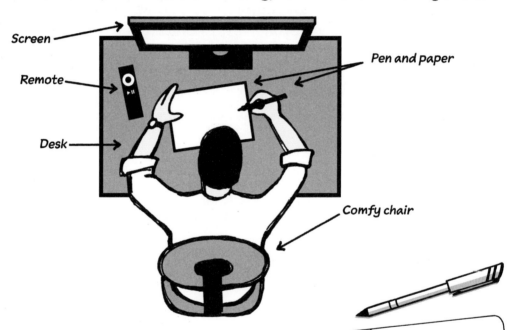

Screen

Remote

Desk

Pen and paper

Comfy chair

 ## CREATE A TITLE

Before the video begins, take a little time to create the title area of your sketchnote. Include directors, writers, actors, and any other relevant details you'd like to capture.

firefly
by Joss Whedon

3 PREPARE FOR THE VIDEO

Prepare yourself for the kind of information you want to capture, such as the overall message, dialogue, character details, relationships, conflict and resolution, presentation, style, or takeaways. To do so, you could make a topic list or create a matrix of characters to reference or add details to as the video plays.

TOPICS

- Captain Mal Reynolds
- Spaceship: Serenity
- The Alliance is in control
- Reavers are crazy!
- Year: 2517
- Sci-Fi Western

THE CREW

Mal Zoë Wash

Kaylee Jayne

4 BEGIN SKETCHNOTING THE SHOW

Begin the video, listening and looking for the kind of information you want to record (Step 3), using lettering, drawings, and text to capture details in a sketchnote.

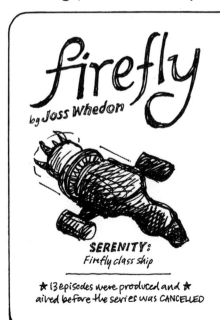

firefly
by Joss Whedon

SERENITY:
Firefly class ship

★ 13 episodes were produced and ★
aired before the series was CANCELLED

THE CREW

Mal Zoë Wash

Kaylee Jayne

TOPICS

- Captain Mal Reynolds
- Spaceship: Serenity
- The Alliance is in control
- Reavers are crazy!
- Year: 2517
- Sci-Fi Western

5 REVIEW YOUR SKETCHNOTE

When the video is done, take a moment to review your sketchnote and think about the presentation. I often see connections at the end that I didn't see during the presentation. Add these observations to your sketchnote.

I've added notes to my sketchnote after watching the TV show.

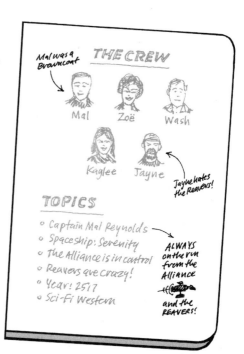

6 FINALIZE THE SKETCHNOTE

Do research, digging deeper into the time, settings, characters, references, or anything else that piques your curiosity after watching. Add these observations to your sketchnote.

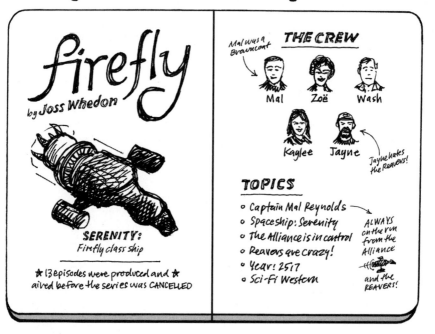

PRACTICAL USES

Here are tips for creating sketchnotes from all kinds of media:

★SKETCHNOTING MOVIES

Movies are typically a few hours long, and tell a full story with multiple characters and settings. Messages are often subtle rather than overt. Sketchnoting movies requires full engagement.

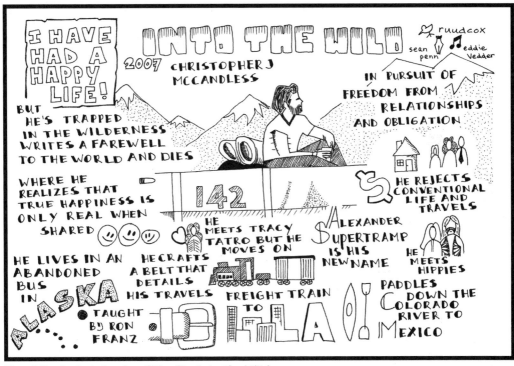

Ruud Cox's sketchnote of the film Into the Wild

With movie sketchnotes, you can focus on overall theme(s), character development, memorable dialogue, or the story's conflict and resolution. Each offers a unique perspective on a movie. Alternately, look for all of these elements for a broader overview of a film's story.

TIP USE THE PAUSE BUTTON!

Control your environment and playback. When you start sketchnoting, use the pause as needed. As you improve your skills, challenge yourself to avoid the pause until you can sketchnote all the way through.

SKETCHNOTE A FAVORITE MOVIE

A good way to enter into movie sketchnotes is to start with one of your favorites. Because you know the story, you'll already have a good sense for the setting, characters, and flow.

Create the movie title and cast of characters on the page, and then document the highlights that are meaningful to you.

CHARACTER MATRIX

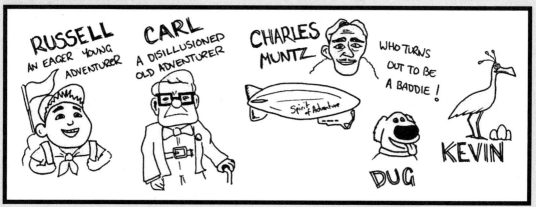

MEMORABLE SCENES

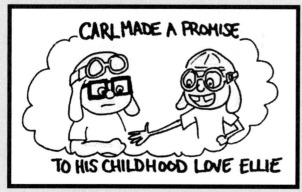

KEY CONFLICT

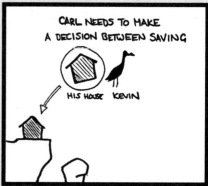

In your sketchnote, capture memorable dialogue, cast members, imagery, and feelings you have watching this film.

QUESTIONS
Did you discover any new details by sketchnoting this movie?
How well were you able to keep pace sketchnoting while the movie played? Did you have to pause?

★SKETCHNOTING TV SHOWS

Serial TV shows are interesting to sketchnote because you can look across a series of sketchnotes for each episode or season and see story arcs and character changes.

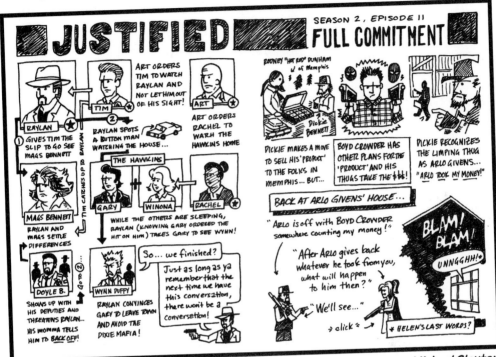

Michael Clayton

As an option, create a character matrix with a dedicated portion of the page. Draw the main characters and their names and any attributes in this area as a reference. Leave space so you can add new characters to the matrix.

Use consistent graphic elements to mark a show's seasons and episodes. Add page numbers and maintain an index as a reference for finding specific sketchnotes later.

TIP USE MEDIA GRAPHICS FOR REFERENCE

Instead of trying to draw characters as a movie or show is playing, take time before you begin to draw the title and main characters from the video case, the show's promo page, or the Internet Movie Database (IMDB). **JUSTIFIED**

SKETCHNOTING LIVE SPORTS ON TV is a good way to test your live sketchnoting skills. You can sketchnote any game—like baseball, football, hockey, soccer, and racing—capturing key plays and players, scoring, and your own reactions to the event. Each live sport provides its own unique challenge that will improve your sketchnoting skills while you capture your experiences visually.

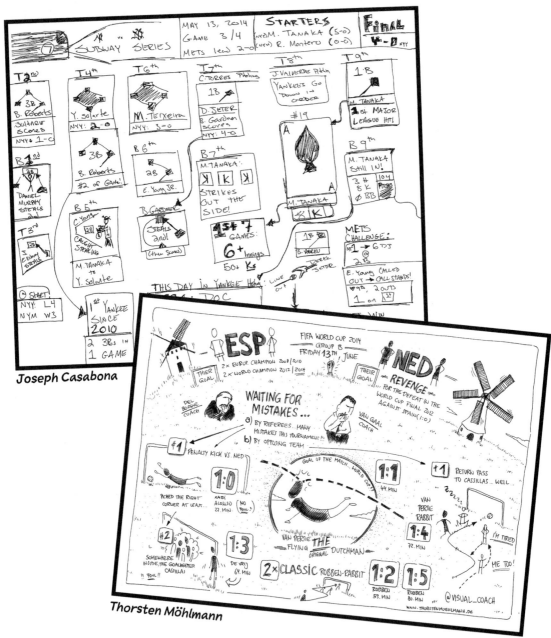

Joseph Casabona

Thorsten Möhlmann

C SKETCHNOTE A FAVORITE TV SERIES

Like the movie exercise, start with a favorite TV show, sketchnoting the characters, story, conflict, and resolution. Capture favorite quotes and characters from the show, using drawings and lettering.

Try sketchnoting an entire season and see what elements of the story and character development emerge as you watch and document the details.

One of my favorite quotes from Firefly.

Season and Espisode numbering icon ideas

QUESTIONS

Did you discover any new details by sketchnoting this show or the entire season? How well were you able to keep pace sketchnoting while the shows played?

C SKETCHNOTE A TEAM SPORTING EVENT

Capture a team event as a sketchnote, detailing important information about the teams, key plays, key players, and score.

QUESTIONS

How did your perception of the game change by being more attentive and by using imagery and text?

★ SKETCHNOTING VIDEO

The same principles for movies and TV shows apply to informational videos, like TED Talks or YouTube videos. However, these videos are generally shorter, and focus on talks or how-to demonstrations.

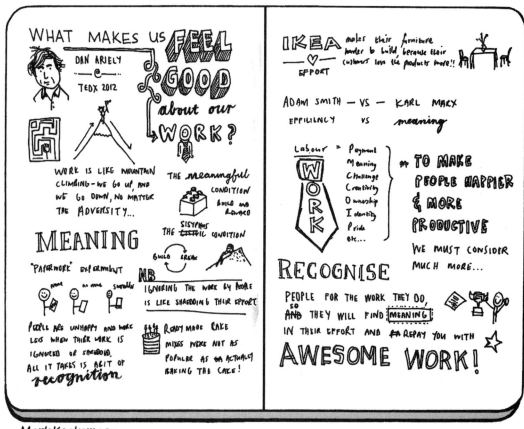

Mark Koekemoer

TIP ## SHORT VIDEOS BUILD YOUR SKETCHNOTING SKILLS

Improve your knowledge while improving your skills by sketchnoting short, recorded videos. You can fit a couple into a lunch break and still have time for your corned beef sandwich.

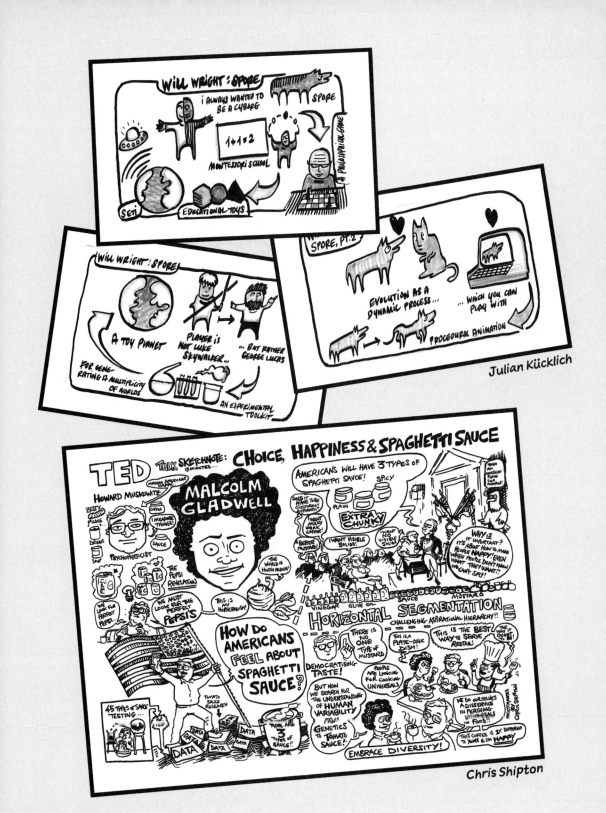

Julian Kücklich

Chris Shipton

★SKETCHNOTING AUDIO

Audio recordings are another convenient media good for sharpening your sketchnoting skills. Podcasts, interviews, and audio books are abundant, and since they all lack video, you can dial in on ideas you're hearing as you sketchnote.

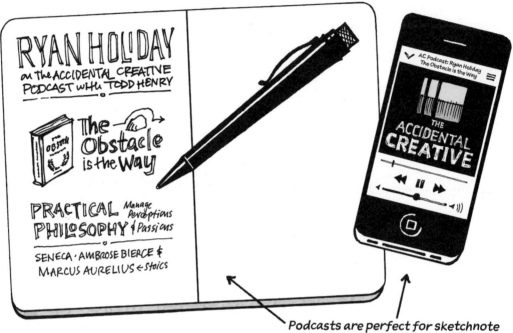

Podcasts are perfect for sketchnote practice because you can pause and restart your session whenever you like

YOU CAN SKETCHNOTE MUSIC, TOO.
Draw the artists' portraits, practice lettering skills on lyrics, or capture the way a song makes you feel using organic hand-drawn images or textures.

I've found sketchnoting music tracks a relaxing, almost therapeutic activity.

I created this sketchnote of a Four Tet song at Dallas/Fort Worth Airport while waiting for a connecting flight

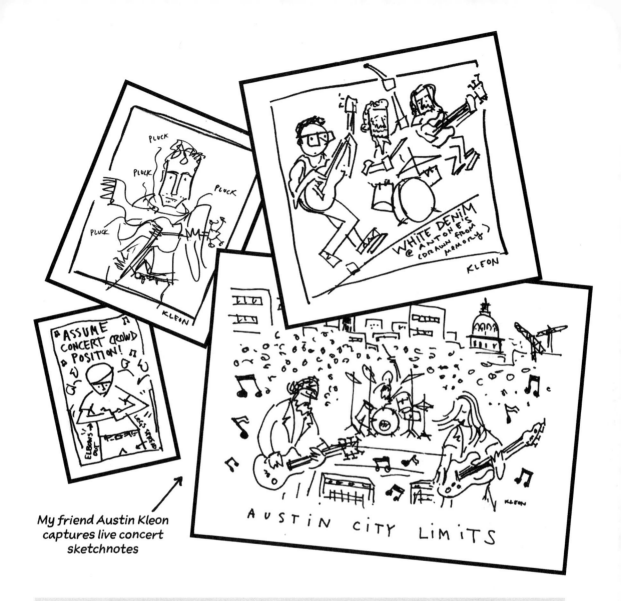

My friend Austin Kleon captures live concert sketchnotes

TIP **STAY LOOSE!**

Sketchnoting music for me is especially fun when I keep my work loose and interpretive rather than tight and structured. Let intuition guide your pen.

CHALLENGE 8.4
SKETCHNOTE YOUR FAVORITE MUSIC

Using sketchnoting techniques while keeping loose, capture your favorite song or album as a sketchnote.

My sketchnote of Moby's track Bring Back My Happiness

QUESTIONS

What words resonated with you? Were the drawings you made light or dark? What feelings did you capture?

•••——————————••

Sketchnoting music is an ideal way to practice your skills in the moments between activities.

★ SKETCHNOTING BOOKS

Books are great sources for sketchnoting. Business and non-fiction books work especially well, but you can sketchnote stories from fiction books just as you do movies.

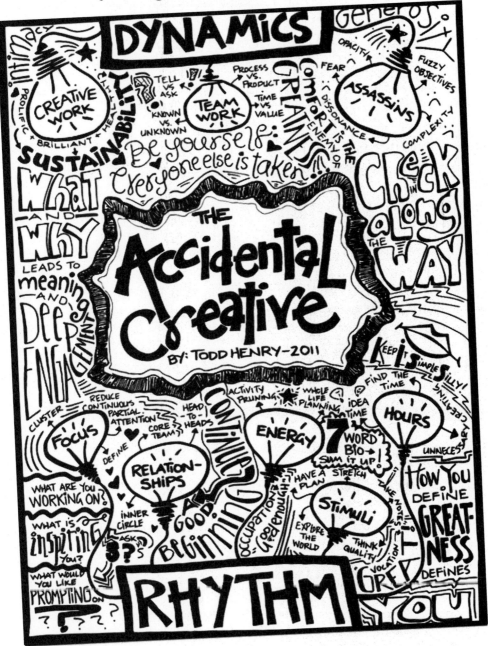

Melinda Walker

WHEN YOU SKETCHNOTE BOOKS, your notes are separate from the books themselves. Even if you loan out or lose a book, your highlights and thoughts about the book's details are preserved.

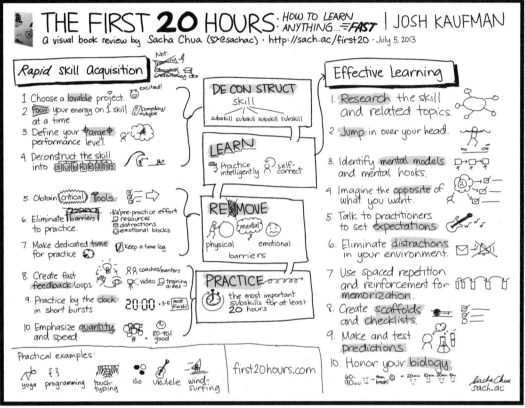

Sacha Chua

Because you focus on the highlights, book sketchnotes are compact and help you recall what you've read. Sketchnotes of your books are also useful for describing books you've read to someone else.

TIP **KEEP A DEDICATED BOOK SKETCHNOTE JOURNAL**

Having all of your book sketchnotes in one journal makes it easy to see how many books you've read and to skim your sketchnotes for a quick brush-up. Keep your book and pen in the locations where you read so you can capture your information whenever you want.

Todd's Visual One Page
Summary Book Notes

SHOW YOUR WORK!

10 WAYS TO SHARE YOUR CREATIVITY AND GET DISCOVERED

AUSTIN KLEON

A NEW WAY OF BEING

IF NOTHING ELSE BECOME AN AMATEUR
LEARN IN THE OPEN
document your progress
share as you go
WITH THE RIGHT PEEPS
Paying close attention to them

AND

SHARE LIKE AN ARTIST

@toddaclarke

YOU DON'T HAVE to be A GENIUS
be part of a scene
COLLABORATE w others
LEARN in the OPEN
if your work is not online
Nothing to LOSE
you'll be DEAD soon
IT DOESN'T EXIST
► Read Obituaries

THINK PROCESS, NOT PRODUCT
Show Behind The Scenes
scoop up the SCRAPS to SHARE & SH ARE something INTERESTING

SHARE SOMETHING small EVERYDAY
Focus on DAYS
better THAN RESUME OR PORTFOLIO
maintain FLOW
not crap
while working your stock
★ BE A SELF-INVENTION machine ✹

OPEN UP YOUR CABINET
of CURIOSITIES
your work has POTENTIAL but your tastes are KILLA
it's what got you in the GAME
Share the work of others
AS IF IT WERE YOUR OWN

YOUR GARBAGE
LIKE what u LIKE
GUILTLESS PLEASURES

your work doesn't speak TELL GOOD ITSELF so → Stories

STRUCTURE is EVERYTHING
once upon a time there was ___.
Everyday ___ One day ___. Because of that ___.
Because of that ___ Until finally ___

► Explain your work
WITH TRUTH & DIGNITY
AND REVEAL SOMETHING disgraceful
strike the adjectives from your BIO

TEACH WHAT YOU KNOW
LEARN TEACH
The minute you learn SOMETHING
Teach it to others
NO TRADE Secrets

DON'T TURN INTO SP AM
O HUMAN
BE vs INTERESTED
HEARTS & MINDS over eyeballs

want FANS, be a FAN 1st
ENERGY DRAIN ♥ or GAIN♥?
The Vampire Test
Nothing beats Face & Face

LEARN TO TAKE A PUNCH
No one ever DIED from a bad review
DON'T FEED THE TROLLS
BL CK COMMENTS
The worst one IS IN YOUR HEAD
No space under paintings for opinions

SELL OUT everybody has to make money $$$
LIKE THIS? Buy Me A Coffee

KEEP A MAILING LIST
Treat it w RESPECT

PAY IT FWD ►►
provide opportunities to others

STICK AROUND

KEEP GOING
continuously
BEGIN AGAIN
WHAT NEXT?
BE A STUDENT AGAIN
NO PREMATURE QUITTING oh my

Todd Clarke

Doug Neill

EXPLORING NEW IDEAS WITH SKETCHNOTES OF TV SHOWS

Doug is a sketchnoter, illustrator, and teacher living in Portland, Oregon. He enjoys sketchnoting talks, interviews, and podcasts, and has been exploring sketchnoting TV shows. He was initially drawn to sketchnoting because it seemed like a creative outlet that packed an intellectual punch.

Doug typically sketchnotes serious stuff: in-depth interviews and talks full of big ideas and complex systems. He sketchnotes to understand and remember those big ideas.

For one experiment, Doug sketchnoted the newly rebooted *Tonight Show* with Jimmy Fallon. His exploration of a late night TV show encouraged him to relax and embrace a lighthearted approach to sketchnoting.

Sketchnoting a TV show was a fun way for Doug to mark the show's new direction and capture a moment in time.

This exploratory approach also offered him a proving ground for new ideas when he sketchnotes heavier topics.

"I use sketchnotes to process new ideas and incorporate them into my life. It's a fun way to close the gap between idea and action."

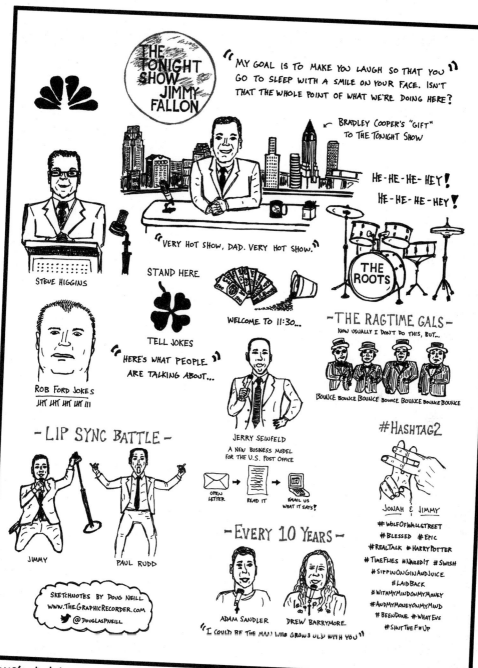

Doug's sketchnote of *The Tonight Show with Jimmy Fallon*

ICONS FOR MEDIA

In the grid below, use squares, circles, triangles, lines, and dots to create icons for each word related to all kinds of media. Skip ahead if you get stuck. The last row is blank so you can create your own icons.

KEY QUOTE	SOUNDTRACK	STORY ARC	EPISODE
66	♫	⌒	SE1 EP2
STORYLINE	SCENE	CONFLICT	RESOLUTION
HOME RUN	TOUCHDOWN	3 POINTER	GOAL
INTERVIEW	ALBUM	AUTHOR	PUBLISHER

RECAP

→ Sketchnotes are a useful way to process, understand, and capture the meaning in movies, TV shows, and other kinds of media.

→ Sketchnoting helps you engage with the story, characters, conflict, and resolution as you watch, listen, or read.

→ You can sketchnote the overall theme(s), character development, memorable dialogue, or the story's conflict and resolution.

→ Sketchnoting live sports is a good way to test your live sketchnoting skills.

→ Audio, like podcasts and music, is another media well-suited for sketchnoting.

→ Sketchnotes are compact and help you recall what you've read and thought.

★ NEXT: ADVANCED TIPS & TECHNIQUES

HANDY TIPS TECHNIQUES

Chapter 9

ADVANCED SKETCHNOTING
TIPS & TECHNIQUES

I've gathered a collection of advanced
tips & techniques to boost your
sketchnoting skills to the next level.

YEP, IT'S TIME FOR
the ADVANCED STUFF!

This chapter is a collection of advanced tips & techniques
my friends and I use in our sketchnoting practice. You can
read it in a single sitting or refer to it as needed.

A key tip or technique can accelerate your sketchnoting
abilities, so I've captured a diverse collection for you.
Hopefully one or more of these will spark your creativity.

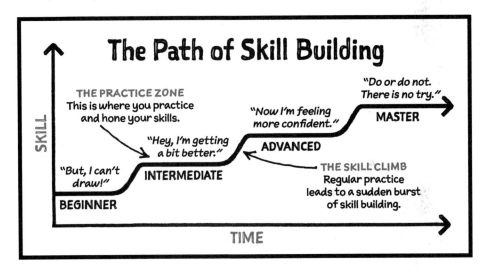

The Path of Skill Building

SKILL

THE PRACTICE ZONE
This is where you practice
and hone your skills.

"Do or do not.
There is no try."

"Now I'm feeling
more confident."

MASTER

"Hey, I'm getting
a bit better."

ADVANCED

"But, I can't
draw!"

INTERMEDIATE

THE SKILL CLIMB
Regular practice
leads to a sudden burst
of skill building.

BEGINNER

TIME

*Whatever level you're at as a sketchnoter, the
best way to get better is to sketchnote as much
as possible. Repetition hones your active
listening, drawing, and lettering skills.*

*STAKE OUT IDEAS

Caching ideas, or temporarily storing new ideas in a mental cache while sketchnoting the idea you've already heard, is a critical sketchnoting skill.

But caching a barrage of ideas can be challenging. I like to stake out an idea kernel—just enough to know what the idea is about without capturing it completely. This could be an icon, a single word, or a sentence. Once an idea stake is on the page with space to expand it later, I can jump to the next idea.

Using stakes, I can keep pace with multiple ideas, returning at the end of the session to expand them.

SETTING
Why does Setting exist? Because God created a place for us to live our lives — JUST FOR US.
A HOME for HUMANS
A PLACE TO LIVE.
Light
INVISIBLE

Light shot into a vacuum never stops moving—timeless.

Stake out a word, then leave space for more and jump to the next idea.

SETTING
Why does Setting exist? Because God created a place for us to live our lives — JUST FOR US.
A HOME for HUMANS
A PLACE TO LIVE.
Light
INVISIBLE, WE ONLY SEE WHAT IT TOUCHES BECAUSE IT'S INVISIBLE, ETERNAL.

Light shot into a vacuum never stops moving—timeless.

When you have time, fill in the remaining space with information.

✳SEEK REPETITION

Key ideas are often accompanied by repetition. Listen for words or ideas that repeat in a talk. If you discover an idea wrapped in repetition and it resonates with you, capture it.

My sketchnotes from SXSW Interactive 2008

I look for repetition in my own thoughts. When an idea pops up again and again, there's a good chance it's an important idea, so I capture it.

✳RESERVE SPACES

If you're sketchnoting ideas where your information must be precise and without error, leave a bit of space for it, jump ahead, and come back when you can insert the correct information.

··─────────··

Reserve space for religious quotes, mathematical formulas, names, or other critical information that must be correct.

in the midst of this
MOSES(علیه سلام)
tells the people
(Quran 14:7)

{ *Leave the sensitive area blank.* }

Umm Sultan

{ وَإِذْ تَأَذَّنَ رَبُّكُمْ لَئِن شَكَرْتُمْ لَأَزِيدَنَّكُمْ وَلَئِن كَفَرْتُمْ إِنَّ عَذَابِي لَشَدِيدٌ ﴿٧﴾ }

Fill in the sensitive area later on

MASS-ENERGY
EQUIVALENCE
*Proposed by Albert Einstein back in 1905:

[┈┈┈┈┈┈]

✳ Annus Mirabilis

MASS-ENERGY
EQUIVALENCE
*Proposed by Albert Einstein back in 1905:

→ $E = mc^2$

✳ Annus Mirabilis

✳PRE-CREATE TITLE PAGES

If you're attending an event with multiple speakers, try creating title pages for every speaker before the event. Estimate the number of pages for each talk and add a little margin just in case one talk goes long.

You can research the correct spelling of all the speakers' names, and if you like, create portraits of the speakers using photos. This trick can help reduce pressure at the event.

*NOOKS ARE FOR DOODLES

Look for small spaces in your sketchnotes to add personality.
If you have extra space at the bottom of a page, circle back at
the end to add thoughts or draw something you didn't have
time for while you were in the heat of your sketchnoting.

SQUEAKY MICE

"IF THEY DON'T SQUEAK
YOU HAVEN'T CHARGED
SQUEAK THEM ENOUGH." - Roger
Black

JUMBLED SKELETONS

The small pieces, loosely joined,
rattle like a SKELETON'S
BONES

LITTLE FARMS

SOCIAL PROOF
Understanding human
herding behavior in
various situations FARMVILLE!

TEETER-TOTTERS

LIFE IS AN
EDUCATIONAL
PLAYGROUND

ANGRY BROWSERS

DEATH of IE 6!"
(and there was much rejoicing!) R.I.P.

ROYAL CROWNS

THE ROYAL 'WE'

BREWING COFFEE

THINK AND BREW
ON THE PROJECT
RATHER THAN JUST
JUMPING IN RIGHT AWAY.

SNAPPY CAMERAS

PHOTOGRAPHIC
MEMORY

*I seek out little nooks and gaps between
paragraphs, whitespace at the end of pages,
or margin spaces to add visual Easter eggs.*

*MISTAKES WILL BE MADE

Sooner or later you're going to make a mistake. That's OK! Here are a few ideas for covering, fixing, or dealing with mistakes:

1. CREATE A SHAPE, like an arrow, right on top of your mistake. Now use the space below the covered mistake to write the correct word or text.

I always seem to misspell this word. *Dark, inky arrow to the rescue!*

If you cover an error with a shape, be creative and have fun with it! *Nobody needs to know your secret.*

2. FIX IT ON THE COMPUTER. If you've misspelled a name or you don't have the option to cover a mistake, you can edit it out using a photo-editing tool on a computer.

Once I misspelled the name of the Coca-Cola CEO in my sketchnotes. I rewrote his name correctly and replaced every instance of the misspelling using Photoshop.

Unusual names can be pretty tricky. *Photoshop to the rescue!*

If you mess something up, don't panic!
It's an opportunity to test your creativity.

3. OWN THE MISTAKE. You can line or cross out errors and rewrite the correct words next to them. Or you can add commentary, like I did on a long list of items Zappos CEO Tony Hsieh shared that I missed.

In the space where the list should have been, I admitted my mistake. There wasn't much to do but own it!

4. AVOID THE MISTAKE. If you carry a smartphone, use it to look up words you are unsure of before it's too late. You can start the word, leave off the part you're unsure of, and finish it later once you have a dictionary available.

Smartphones are powerful tools that help you correct your spelling and research the people, places, and things you're sketchnoting.

Your smartphone dictionary app could save you time later on.

*INTERNET RESEARCH & REFERENCE

If you're stuck trying to draw something unusual or difficult, lean on the Internet. A Google Images search or stock photo website can be a handy reference for whatever you need to draw.

When I can't even imagine what to draw, I'll type keywords that describe an idea into Google Images to search for ideas.

Check out font websites for references on creating lettering using their typeface collections.

✳SHARING SKETCHNOTES

It can be great fun sharing your sketchnotes during or right after an event. Here are a few ideas:

1. SHOW YOUR WORK TO THE SPEAKERS. You'll have a good chance to talk about what you've heard and captured. Have them sign your sketchnotes and offer to email a copy to them.

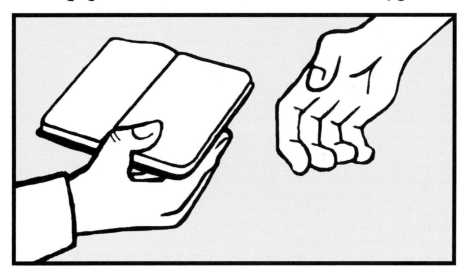

2. SHARE YOUR WORK VIA SOCIAL MEDIA. If meeting the speaker isn't an option, post a photo of your sketchnotes using social media. Add the speaker's username so they can see your work. Speakers generally like seeing their talks sketchnoted and may share your work with their friends.

3. SHARE YOUR WORK VIA EMAIL. My friend Jessica Esch likes to track down the person's email, sending the link of her sketchnotes directly. Taking a little extra time can have a big payoff and may build your network.

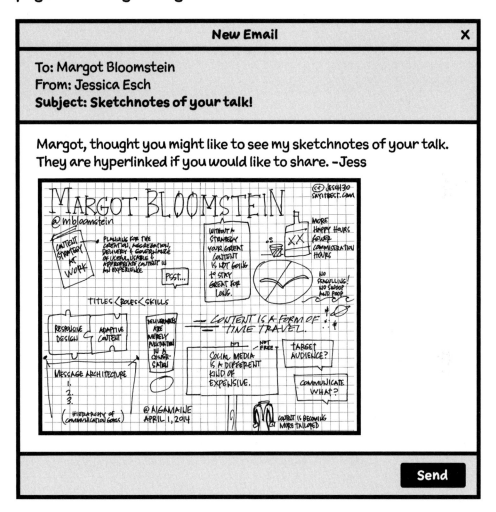

Sharing your sketchnotes is a fun way to connect with speakers and to show your work to fellow sketchnoters.

ADVANCED LETTERING TECHNIQUES

I've heard lots of requests for more typefaces you can hand-letter in sketchnotes, so here are tutorials to get you started.

✳ DRAWING SERIF TYPE

Serif typefaces feature serifs, or little feet, at the ends of each character that add a little flair to your headlines. Here's how I create serif lettering:

STEP 1	STEP 2	STEP 3
Draw simple, single-line letter shapes as a basic framework.	*Thicken strokes and add serifs, using the typeface sample shown on the right.*	*Fill in the completed letter, adjusting the shape as needed.*

CREATE A WORD IN SERIF LETTERING

Serif lettering is regular and logical once you know the structure.

Re-create thick and thin sections of each letter using the sample typeface for reference.

The amount of space between pairs of letters is called letter spacing.

CENTURY SCHOOLBOOK from Monotype is a helpful typeface reference you can use to create serif lettering:

UPPERCASE

ABCDEFGHIJ
KLMNOPQRS
TUVWXYZ

LOWERCASE

abcdefghijklmn
opqrstuvwxyz

NUMBERS & PUNCTUATION

1234567890
?!&%$@#()+-

✳DRAWING SLAB SERIF TYPE

Slab serif is a variation of serif type with more geometric shapes and thick, straight serifs. Here's how I create slab serif lettering:

STEP 1	STEP 2	STEP 3
Draw simple, single-line letter shapes as a basic framework.	Add strokes and slab serifs, using the typeface sample shown on the right.	Fill in the completed letter, adjusting the shape as needed.

CREATE A WORD IN SLAB SERIF LETTERING
Slab serif lettering is a bit bolder than traditional serif typefaces.

It's helpful to use the serifs you've already drawn as a reference for drawing adjacent letters.

ROCKWELL from Monotype is a helpful typeface reference you can use to create slab serif lettering:

ABCDEFGHIJK
LMNOPQRSTU
VWXYZ

LOWERCASE

abcdefghijklm
nopqrstuvwxyz

NUMBERS & PUNCTUATION

1234567890
?!&%$@#()+-

✳ DRAWING SCRIPT TYPE

Script can be time consuming to draw, so I like to use it when I'll have extra time to create it before or after a sketchnote. Here's how I create script lettering:

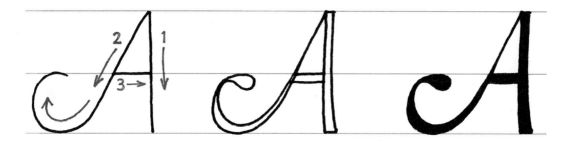

STEP 1
Draw simple, single-line letter shapes as a basic framework.

STEP 2
Thicken strokes and add other details, like the bulb at the end of the curve.

STEP 3
Fill in the completed letter, adjusting the shape as needed.

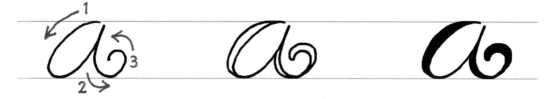

CREATE A WORD IN SCRIPT LETTERING
Script is unique because you can connect the letters together.

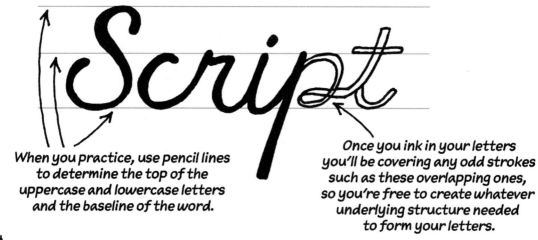

When you practice, use pencil lines to determine the top of the uppercase and lowercase letters and the baseline of the word.

Once you ink in your letters you'll be covering any odd strokes such as these overlapping ones, so you're free to create whatever underlying structure needed to form your letters.

SUSA LIGHT from Hubert Jocham is a helpful typeface you can reference as you practice creating script lettering:

UPPERCASE

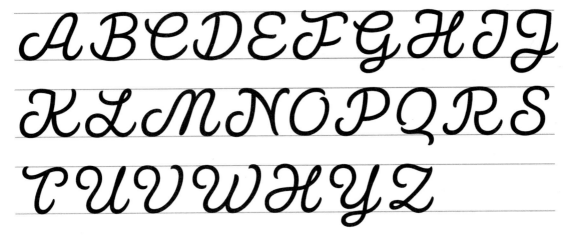

$$\mathcal{A}\ \mathcal{B}\ \mathcal{C}\ \mathcal{D}\ \mathcal{E}\ \mathcal{F}\ \mathcal{G}\ \mathcal{H}\ \mathcal{I}\ \mathcal{J}$$

$$\mathcal{K}\ \mathcal{L}\ \mathcal{M}\ \mathcal{N}\ \mathcal{O}\ \mathcal{P}\ \mathcal{Q}\ \mathcal{R}\ \mathcal{S}$$

$$\mathcal{T}\ \mathcal{U}\ \mathcal{V}\ \mathcal{W}\ \mathcal{X}\ \mathcal{Y}\ \mathcal{Z}$$

LOWERCASE

a b c d e f g h i j k l m n

o p q r s t u v w x y z

NUMBERS & PUNCTUATION

1 2 3 4 5 6 7 8 9 0

? ! & % $ @ # () + -

*DRAWING CONDENSED TYPE

Condensed typefaces are handy for fitting long headlines into short spaces. Here's how I create condensed lettering:

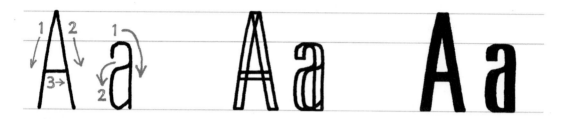

STEP 1
*Draw simple,
single-line letter shapes
as a basic framework.*

STEP 2
*Double the strokes and cap the
ends, using the typeface
sample shown on the right.*

STEP 3
*Fill in the completed
letter, adjusting the
shape as needed.*

*DRAWING EXTENDED TYPE

Expanded typefaces are ideal for spreading short headlines into long spaces. Here's how I create extended lettering:

STEP 1
*Draw simple
single-line letter shapes
as a basic framework.*

STEP 2
*Double the strokes and cap
the ends, using the typeface
sample shown on the right.*

STEP 3
*Fill in the completed
letter, adjusting the
shape as needed.*

MYRIAD CONDENSED by Adobe is a helpful typeface reference you can use to create condensed lettering:

UPPERCASE

ABCDEFGHIJKLMNOPQRSTUVWXYZ

LOWERCASE

abcdefghijklmnopqrstuvwxyz

NUMBERS & PUNCTUATION

1234567890?!&%$@#()+-

EUROSTILE EXTENDED by Linotype is a helpful typeface reference you can use to create extended lettering:

UPPERCASE

ABCDEFGHIJKLMN
OPQRSTUVWXYZ

LOWERCASE

abcdefghijklmnopq
rstuvwxyz

NUMBERS & PUNCTUATION

1234567890?!&%$@#()+-

✳DRAWING 3D TYPE

Use 3D lettering to provide depth and weight. It takes more time, but the effect is worth the effort. Here's how I create 3D lettering:

STEP 1
Draw the block letter shape first.

STEP 2
Add strokes horizontally and on an angle for a 3D effect.

STEP 3
Fill in the 3D portion of the letter for depth.

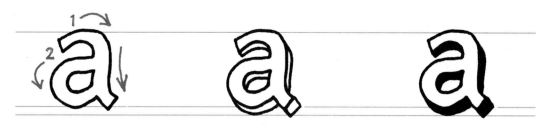

3D LETTER STRUCTURE DIAGRAM
Here are a few tips for creating consistent 3D lettering :

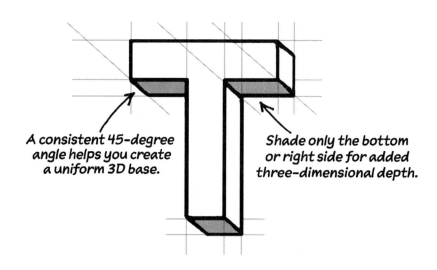

A consistent 45-degree angle helps you create a uniform 3D base.

Shade only the bottom or right side for added three-dimensional depth.

FUTURA SHADED from Scangraphic is a helpful typeface reference you can use to create 3D lettering:

ABCDEFGHIJKL
MNOPQRSTUV
WXYZ

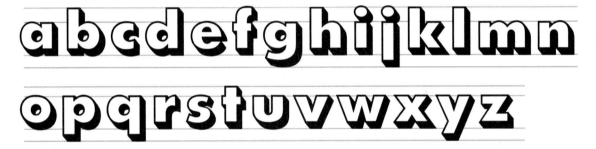

abcdefghijklmn
opqrstuvwxyz

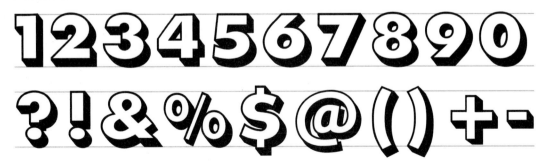

1234567890
?!&%$@()+-

*SLOW, FAST, MEDIUM EXERCISE

My friend Brandy Agerbeck has a useful exercise to improve your lettering speed from her book *The Graphic Facilitator's Guide*. In this exercise, break a sheet of paper into 3 parts. Now, write the alphabet in 3 ways:

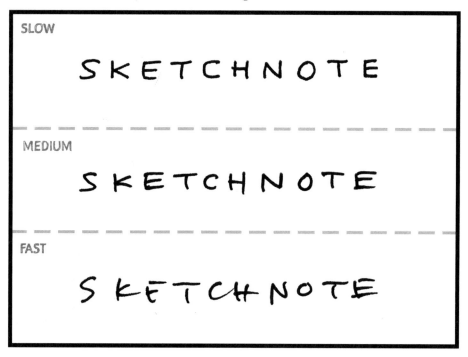

Look at the slow and fast options. Slow is nice but too slow for sketchnoting. Fast is probably sloppy but, well, fast.

Now aim at finding a middle ground between slow and fast as you write the alphabet in the middle of the page. This is the speed you should aim for in your sketchnotes.

Practice is the best way to improve your handwriting speed and quality. The more you work at writing consistently, the better you'll get at it.

ADVANCED PEOPLE DRAWING

In *The Sketchnote Handbook*, I shared the Dave Gray and Star Methods of drawing people. Here is a new method to try:

*TWO PEN PEOPLE

My friend Jason Alderman uses two pens when drawing people. He'll draw a loose, sketchy person with a light color pen, and then draw heavier black lines to tighten up the details on top of the color lines.

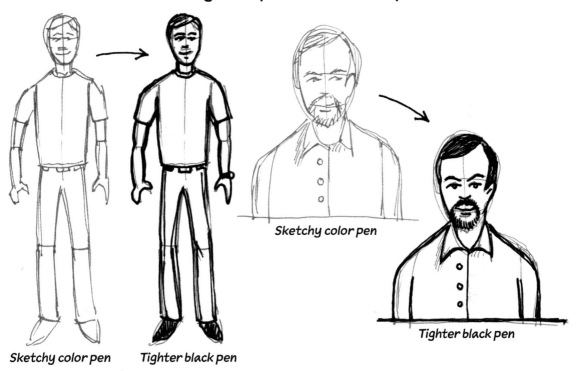

Sketchy color pen

Tighter black pen

Sketchy color pen *Tighter black pen*

CHALLENGE 9.1

ⓒ DRAW LOTS-O-PEOPLE

Draw 50 people in multiple poses: sitting, running, presenting at a board, people working together, and so on.

QUESTIONS
How did your drawing quality change between the first and the fiftieth drawing? What patterns emerged from this challenge?

ADVANCED FACE DRAWING

Faces are sometimes tough to draw. I've gathered a collection of tips to make drawing faces a bit easier:

✳ DRAW THE HEAD'S SHAPE

Look at the person's head for the shape. Is it oval or rectangular? Do they have a long chin, wide forehead, large eyes or mouth? Capture the shape, and then add details.

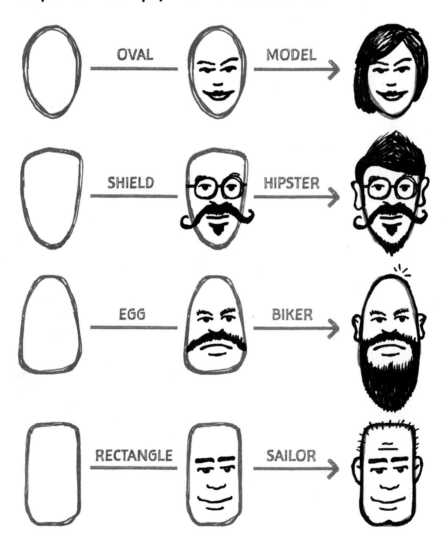

OVAL → MODEL →

SHIELD → HIPSTER →

EGG → BIKER →

RECTANGLE → SAILOR →

*EMPHASIZE DOMINANT FEATURES

Look for the most dominant features and emphasize them. It could be a full beard, fuzzy hair (or no hair), long nose, or bushy eyebrows. Whatever it is, capture it and work on the rest of the face from there.

CHALLENGE 9.2
© DRAW LOTS-O-FACES

Draw 50 detailed faces, using your friends, family, and TV or movie star faces for reference.

QUESTIONS
How did your drawing quality change between the first and the fiftieth drawing? What patterns emerged from this challenge?

✳BUILD THE FACE IN SECTIONS

Another way to create a face is by breaking it into sections.

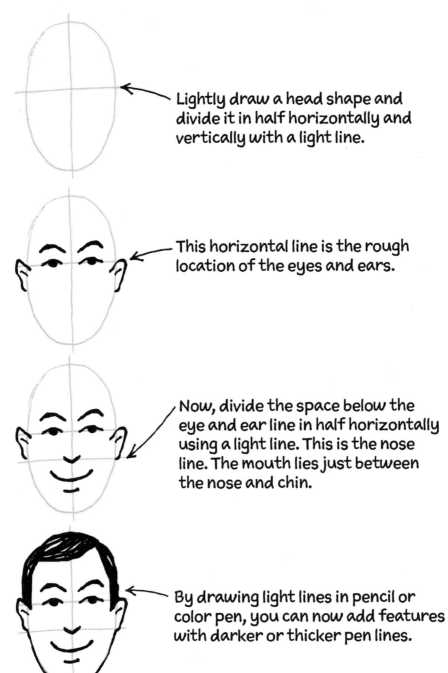

Lightly draw a head shape and divide it in half horizontally and vertically with a light line.

This horizontal line is the rough location of the eyes and ears.

Now, divide the space below the eye and ear line in half horizontally using a light line. This is the nose line. The mouth lies just between the nose and chin.

By drawing light lines in pencil or color pen, you can now add features with darker or thicker pen lines.

ADVANCED METAPHORS

In this section we'll delve deeper into metaphors, or figures of speech that use the attributes of one idea to describe another unrelated idea. I've gathered tips and exercises to help you create memorable, effective metaphors.

*KEYS TO CREATING METAPHORS

USE CRAZY IMAGERY TO PLANT IDEAS IN YOUR MIND.
Crazy imagery acts as a helpful, memory-boosting mnemonic device.

COMBINE ABSURD, UNRELATED IDEAS.
The unexpectedness of a strange idea combination makes those concepts stay with you, like chocolate-covered lutefisk.

BE HUMOROUS.
A funny metaphor not only makes you laugh, but helps you to remember complex ideas.

WORKSHEET 9.1
METAPHOR WORKSHEET
This grid of cells includes some metaphors for reference. Half of the cells have defined metaphors to challenge you to create a drawing, while the other half are open so you can describe and draw your own metaphors.

CABIN FEVER	LAME DUCK	BOILING MAD	TUNNEL VISION
SNAKE OIL	HOLY GRAIL	HEART OF GOLD	CATCH-22

C CHALLENGE 9.3
METAPHOR CHALLENGE
Create several different ideas for each metaphor drawn above.

QUESTIONS
How did you solve the challenge metaphors? What are some metaphors you might use in your sketchnoting?

ADVANCED ICONS

Icons are compact ways to capture ideas. It's a good practice to create icons before you need them. This way you can consider multiple ideas until you find the best one. This practice lets you create a visual library of icons in your memory or in the back of your notebook for reference.

SIMPLE	MEDIUM	COMPLEX

CREATE AN ICON LIBRARY

In the back of your notebook or in a dedicated notebook, create an icon library of ideas you frequently encounter. Divide the pages into a grid that can accommodate 4 or 5 icons per row. Write the concept above, and then draw out several ideas for the icon below the description.

AWARD	ANALYTICS	QUOTE	KEY
GIFT	EDUCATION	POISONOUS	DOWNLOAD

DEAD TOPIC	ALERTS	PRICING	SETTINGS
FLAGGED	FILTER	RECHARGE	PIN

LEARNING

NEW SKILLS

CAN BE TOUGH

You can do it!

REMEMBER:

Experiments

NOT
ASSIGNMENTS!

TRY NEW THINGS,
DON'T FEAR MISTAKES,
AND HAVE FUN!

INDEX

JOIN ME *and* THE SKETCHNOTE COMMUNITY!

There's a friendly community of people just like you who would love to see your sketchnotes. Here are two great places to share your sketchnotes:

THE FLICKR GROUP

The Sketchnote Handbook & *The Sketchnote Workbook* Flickr group provides a place to share your sketchnotes, from worksheets and challenges to samples of your own independent sketchnote work:

→ flickr.com/groups/thesketchnotehandbook

SKETCHNOTE ARMY

The Sketchnote Army is a website dedicated to finding and showcasing the sketchnote work of people from around the world.

→ sketchnotearmy.com

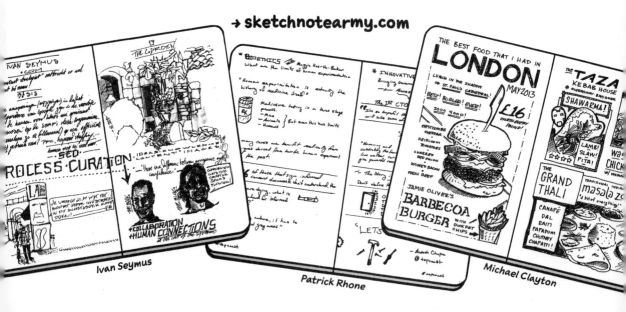

Ivan Seymus

Patrick Rhone

Michael Clayton